ALSO BY SAM STEPHENSON

Bull City Summer: A Season at the Ballpark

*The Jazz Loft Project: Photographs and Tapes of W. Eugene Smith
from 821 Sixth Avenue, 1957–1965*

Dream Street: W. Eugene Smith's Pittsburgh Project

W. Eugene Smith 55

GENE SMITH'S SINK

GENE SMITH'S SINK

A WIDE-ANGLE VIEW

•

SAM STEPHENSON

FARRAR, STRAUS AND GIROUX NEW YORK

Farrar, Straus and Giroux
18 West 18th Street, New York 10011

Several chapters in this book were originally published, in somewhat
different form, in *The Paris Review.* A large portion of the Sonny Clark
chapter was originally published, in somewhat different form, in *Tin House.*

Grateful acknowledgment is made for permission to reprint the following
material: Excerpt from *The Diary of Anaïs Nin, Volume Four: 1944–1947.*
Copyright © 1971 by Anaïs Nin. Reprinted by permission of Houghton
Mifflin Harcourt Publishing Company. All rights reserved.

Library of Congress Cataloging-in-Publication Data
Names: Stephenson, Sam, author.
Title: Gene Smith's sink : a wide-angle view / Sam Stephenson.
Description: First edition. | New York : Farrar, Straus and Giroux, 2017.
Identifiers: LCCN 2016052191 | ISBN 9780374232153 (hardback) |
 ISBN 9781429944458 (e-book)
Subjects: LCSH: Smith, W. Eugene, 1918–1978. | Smith, W. Eugene,
 1918–1978—Correspondence. | Smith, W. Eugene, 1918–1978—
 Friends and associates. | Photojournalists—United States—Biography. |
 BISAC: BIOGRAPHY & AUTOBIOGRAPHY / General.
Classification: LCC TR140.S627 S74 2017 | DDC 770.92 [B]—dc23
LC record available at https://lccn.loc.gov/2016052191

Designed by Jonathan D. Lippincott

Our books may be purchased in bulk for promotional, educational, or business use.
Please contact your local bookseller or the Macmillan Corporate and Premium Sales
Department at 1-800-221-7945, extension 5442, or by e-mail at
MacmillanSpecialMarkets@macmillan.com.

www.fsgbooks.com
www.twitter.com/fsgbooks • www.facebook.com/fsgbooks

1 3 5 7 9 10 8 6 4 2

To Allan Gurganus

Tell all the truth but tell it slant—
Success in Circuit lies . . .
 —Emily Dickinson

I was once present at a lecture that Eugene Smith gave to some
students at a school of photography. At the end, they protested
because he had made no mention of photography, but had spoken
the whole time about music. He calmed them by saying that what
was valid for one was valid for another. —Henri Cartier-Bresson

We might have been educated to be extremely selective in
terms of our attention. For example, Marion Milner talks about
"wide-angled attention." She says, "If you want to paint an object
look at everything around the object but not at the object itself."
So there wouldn't be over-focus, over-concentration. There'd be
the possibility, say, of being surprised. —Adam Phillips

CONTENTS

GENE
SMITH'S
SINK

PROLOGUE

In 1977, on the sidewalk outside his loft on Twenty-third Street in Manhattan, the fifty-eight-year-old W. Eugene Smith watched from a wheelchair as some two dozen volunteers—mostly young photography students paying homage—loaded his life's work into two shipping trucks. Twenty-two tons of materials were packed and driven across the country to a new photography archive called the Center for Creative Photography at the University of Arizona. When the shipment arrived in Tucson, it filled a high school gymnasium and spilled into outlying rooms. The piles were waist-high from wall to wall with aisles cleared for walking space. Most of the boxes were unmarked and everything was covered in New York City loft grit that had accumulated for decades.

Included in the shipment were three thousand matted and unmatted master prints; hundreds of thousands of meticulous 5 x 7 work prints; hundreds of thousands of negatives and contact sheets. There were hundreds of pocket spiral notebooks and thousands of 3 x 5 note cards with scribbled notes; maps and diagrams from all over the world; and hundreds of boxes of clipped

magazine and newspaper articles. Smith wrote hundreds of fifteen-page single-spaced letters to family, friends, and people he barely knew, and he mimeographed copies before mailing them. There were dozens of cameras, various pieces of darkroom equipment, trash cans and boxes full of loose lens caps, rubber bands, and paper clips. Smith also had 25,000 vinyl records and 3,750 books.

The shipment also included 1,740 dusty reels of tape containing, we now know, around 4,500 hours of audio recordings Smith made—surreptitiously, for the most part—in his previous loft, on Sixth Avenue and Twenty-eighth Street, in the wholesale flower district, between 1957 and 1965. This loft building was a legendary after-hours haunt of jazz musicians such as Thelonious Monk, Zoot Sims, Roland Kirk, Paul Bley, Roy Haynes, Chick Corea, Lee Konitz, and Alice Coltrane, as well as classical musicians such as Steve Reich. Also dropping by the nocturnal scene were the likes of Doris Duke, Norman Mailer, Anaïs Nin, Diane Arbus, Robert Frank, Henri Cartier-Bresson, and Salvador Dalí. But for each famous person there were dozens of obscure musicians, pimps, prostitutes, drug addicts and dealers, dropouts, hustlers and thieves, beat cops and building inspectors, photography students, frame makers, fire extinguisher technicians, and countless other figures.

The tapes contain absurd oddities such as eight continuous hours of random loft sounds in 1964—Smith puttering around doing not much of anything, making paranoid phone calls, street noise floating through the windows, the constant trickle of water from his darkroom sink.

Smith recorded myriad sounds from TV and radio, too: James Baldwin, MLK, and Malcolm X on a panel; MLK giving speeches in Birmingham; JFK's election and assassination; Walter Cronkite reading Cold War news; the Cuban Missile Crisis; the 1960 World Series between the Yankees and the Pirates; Cassius Clay's first

fight versus Sonny Liston; Dorothy Parker reading her work; Leontyne Price singing Verdi's Requiem; late-night Long John Nebel talk shows with callers talking about UFOs and alien abductions; Ed Sullivan; Mr. Magoo; Beckett's *Waiting for Godot* and *Krapp's Last Tape*; and Jason Robards reading Fitzgerald's "The Crack-Up"; among many others.

In Tucson, when this shipment arrived, the ill, damaged Smith rolled around the gymnasium in a wheelchair, complaining that things were missing, and expressing suspicion toward the university officials who were trying to make sense of the chaos.

In pictures from this time, Smith looks like a man three decades older. The lectures he gave as part of the university's acquisition of his archive were recorded, and on these tapes one can hear him dying. He mumbles, slurs words, and struggles to breathe. But he's still making wisecracks. *I never make jokes at the beginning of my lectures*—(pause, deep breath)—*because I usually manage to get plenty of laughs without trying* (laughter in the room).

A doctor's report from two years earlier indicated that Smith had diabetes, cirrhosis of the liver, severe hypertension with an enlarged heart, and chronic lower leg and dermatitis problems due to bad blood circulation. The doctor wrote "NO ALCOHOL" on the report and underlined it. When Smith gave his lectures in Tucson, students noticed that he sipped glasses of vodka or scotch and ice.

In addition to alcohol, Smith was addicted to amphetamines and prescription and over-the-counter pills, for most of his adult life. The pills fueled marathon sessions in the darkroom; three, four, five days in a row without sleeping. There is evidence he used something injected through a needle (probably a more potent amphetamine) during his loft years.

Less than a year after Smith and his archive arrived in Tucson,

he was at a convenience store buying food for his cats when he collapsed. A rescue squad took him to the hospital.

His next-door neighbors in Tucson fed his cats while he was hospitalized, and the condition of his house was so awful they were compelled to photograph it. The pictures are gross—stomach-turning, some of the worst living conditions I've ever seen—and sad. Mounds of moldy dishes, filthy clothes and linens, garbage everywhere, and cats doing the best they can. The pictures of this house make Smith's legendarily messy, funky New York loft look livable.

Smith died a few days later. His death certificate read "stroke" but, as was said of the immortal jazzman Charlie Parker, Smith died of "everything." He was flat worn out. He'd given up. He left eighteen dollars in the bank, and forty-four thousand pounds of materials.

o

After twenty years of research—twenty-four cross-country visits to Smith's archive, and more than five hundred interviews in twenty-six states and Japan—I finish writing this book in Durham, North Carolina, standing at my bar-high desk made from Gene Smith's eight-foot stainless-steel darkroom sink, the same sink he installed in his Sixth Avenue loft in the late 1950s. Behind my desk sits his custom-made heart-of-pine light board that he used to inspect negatives.

Smith's son Patrick, the toddler holding hands with his little sister, Juanita, in the iconic 1946 photograph *The Walk to Paradise Garden*, sold his father's equipment to me in 2006 when he and his wife, Phyllis, were cleaning out their basement in Pleasant Valley, New York. *The deal is*, he told me, *you have to take all of it. You can't cherry-pick the valuable things. And if I ever want it back, you have to sell it to me at the same price.* A few weeks later, Pat and

his son Link loaded a truck and drove the equipment down to Durham.

I wanted Smith's darkroom sink to become useful for me, too, but not in his original manner of using it. It's resting in a metal frame made for me in 2012, a desktop formed by a sheet of security glass resting on top of the basin, held in place by rubber bumpers. If somebody wanted to use it as a darkroom sink again, the integrity of the original object is maintained.

o

Smith's astonishing darkroom effort—the careful shading of his tones and the warm texture of his prints—is an archival marvel to experience. But more than his photographs, I was motivated by his mysterious, inexplicable, invaluable tape recordings made in the isolated squalor of his "jazz loft," where *Life* executives and photography officials and other more reasonable associates reckoned Smith had retreated once and for all to lose his mind. They weren't entirely wrong.

Smith's loft years were marked by his *sink*, a deep fall into addictions and quixotic documentary obsessions and, ultimately, self-destruction. In the process, he produced some of his strangest and most alluring work, which, taken together, measured by time and the quantity of materials, outstrips the rest of his life's work combined, capturing the beautiful and haunted and troubled lives and times inside and around the loft building in a neighborhood that was desolate by night, bustling with shops peddling perishable flowers by day, all of it a mirror and symbol of his inner turmoil.

Smith's journalistic practice of going out into the world to document assigned subjects in places foreign to readers of *Life* magazine and returning with a story (on the front lines of combat in World War II, a rural doctor in the Colorado Rockies, a rural

African-American midwife in South Carolina, Albert Schweitzer in equatorial Africa) was turned around in the loft, where he didn't go anywhere. He used the same obsessive passion, perhaps even more of it, to document everything right around him. The results offer a reflection more intimate than his journalism, his focus more telling when not on assignment.

Somewhere along the way I realized I was getting a clearer picture of Smith by averting my focus slightly to the side of him, the way you can see stars in the sky more clearly by doing the same thing, the results here an experiment in this wide-angled vision.

PART I

1

MEXICANA

On the night of Friday, April 21, 1939, Gene Smith went to the Forty-Sixth Street Theatre between Broadway and Eighth Avenue to photograph the opening of a new show. The assignment came through his agency, Black Star, and he expected the resulting pictures to run in *Life*, the exciting new magazine that began publishing his work regularly in 1938 when he was only nineteen years old. He was now twenty and on freelance retainer.

Opening was *Mexicana*, a revue sponsored by the Republic of Mexico and featuring 142 musicians, singers, actors, and dancers. Twelve days earlier, a train arrived at Penn Station carrying nearly two hundred performers, crew members, and diplomats from Mexico City, dozens of cases of costumes, murals of painted scenery, and two chickens that were intended to fight onstage (U.S. laws prevented it). According to reports, "nine-tenths" of the entourage had never visited the United States.

Mexicana was the first Broadway show presented by a foreign government. It arrived in conjunction with Mexico's exhibit at the heralded New York World's Fair, which opened a few days later in Queens. Ominous economic and political undertows were

spreading around the globe—and the 1938–39 New York theater season had been dismal, even by standards set earlier in the Depression—but the much-anticipated Fair generated a breeze of hope and goodwill around the city.

At the time, Smith and his mother, Nettie Lee Caplinger Smith, age forty-nine, lived together on Fordham Road in the Bronx, near the Botanical Garden. Gene endured less than a year at Notre Dame on a photography scholarship before dropping out and moving to New York. Nettie followed, handling her son's schedule and finances, and she assisted him in the darkroom. A devout, converted Catholic, she was domineering and stern. Gene's cousins in Kansas feared her. From her he inherited an indomitable willpower—hers, grim and authoritative; his, more chameleonic and enigmatic; the shared core quality a cord that riddled them.

Gene soon was hired to be a staff photographer at *Newsweek*, but he was fired for using the new, more flexible "miniature" 2¼-inch-square cameras that the magazine prohibited. In a depressed era when most young adults grasped for any foothold they could find, the nineteen-year-old Smith had already given up a major university scholarship and challenged a prominent magazine's editorial boundaries until he was fired. He wouldn't follow his father's burdened, suit-and-tie path to an early death; he might kill himself, but in a different way.

Smith was a normal-size man, five foot nine or ten (according to his passports), with sandy hair, and he wore glasses. Like most photographers who lug cameras, tripods, and bags of equipment, his upper body was wiry strong. He spent hours per day holding cameras to his face like a curl exercise and maneuvering the lenses, dials, levers, and buttons with his fingers, forging sinews in his biceps, forearms, and hands. Then in the darkroom he spent many more hours rooting his hands around the devel-

oping reels, the enlarger, the sinks and basins, and the clothes-line where he hung prints. Near the end of his life, in his fifties, when doctors said he had the distressed organs of a man several decades older, his hands and arms remained those of a professional gardener or auto mechanic.

On the afternoon of April 21, 1939, the temperature in Central Park peaked at fifty-nine degrees and there were scattered spring showers. By the time the doors opened at the Forty-Sixth Street Theatre, a dark drizzle filtered the streetlights and damp-ened the sidewalks. The seats were full but not sold-out.

The Forty-Sixth Street Theatre (now the Richard Rodgers) was designed by the most prolific architect in the Broadway the-ater district, Herbert J. Krapp, during the burgeoning 1920s. It was grand and elegant, typical of American glamour of the time, with neo-Renaissance structures and extensive, ornate terra-cotta details.

What happened inside the theater that night was described this way by Celestino Gorostiza, the director of fine arts of the Mexican Ministry of Education: "*Mexicana* aims to cover Mexi-can life in song and dance and pantomime from the earliest Aztec times down to today, and at the same time it brings together a kind of kaleidoscope of all the costumes and customs and leg-ends of every geological division of the republic."

The curtain rose at 8:30 p.m. Over the next three-plus hours dramatic colors were displayed in mural backdrops created by follow-ers of Diego Rivera. Bright costumes crisscrossed the stage—female dancers wearing woven rainbow sashes and wraparounds, with colorful ribbons and hoop earrings, or dark colored dresses with intricate trimming and glistening sequins and beads sewn into the fabric. The male dancers and musicians wore traditional Spanish charro suits, in a variety of colors, with silver studs on their pants and big bows tied around their necks. There were

also more traditional outfits with men wearing ponchos and women dark skirts with aprons and white embroidered shirts. There were big, straw-colored sombreros with a spiral weave for men and women, and various head wraps, often flowered, for the women.

Reviews of *Mexicana* emphasized the visuals, using words and phrases such as "sun-kissed colorful," "glowing loveliness," "brilliant colors." The "flow" of the "native costumes" impressed one writer and the "primitive vitality" of the scenery another. In virtually every review, all written by men, the "lovely girls" were mentioned; the "almond-skinned beauties," wrote one, "the fetching senoritas," wrote another. One notice mentioned that "[*Mexicana*] boasts of [dancer] Marissa Flores among other appealing items."

The subtitle of *Mexicana* in a hand-typed rehearsal outline was "A Mexican Folk Show," but in the published Broadway *Playbill* it was "A Musical Extravaganza." The change may have been made by publicists seeking to cut off at the pass condescending comments based on ethnicity, which came about anyway. In the New York *Daily News*, John Chapman called the show "one of the most disarmingly naïve entertainments ever presented on a Broadway stage surfeited with professional artifice." In *The New York Times*, Brooks Atkinson said that the show "lacks showmanship" and that it needed a professional director (from New York, no doubt, he meant) to "make something dynamic out of it."

Several critics pointed out the merits of *Mexicana*—Flores and her dance partner José Fernandez, and a comic baseball pantomime—but then they complained that it was overlong and monotonous, its initial energy and vitality diluted in the second act. The reviews stress the show's folk, comic, and visual elements, not the music. The only musician singled out was the guitarist Vicente Gomez, a flamenco virtuoso who had performed at New York's Town Hall the year before.

The producers of *Mexicana*, in their eagerness, may have tried to do too much. The show's *Playbill* indicates there were twenty-seven scenes in two acts. A surviving rehearsal outline listed only twenty scenes. Seven scenes were added, perhaps during the twelve days between arriving in New York and opening night. Maybe this was a mistake, maybe the extra scenes made the production too long. But it's also possible that the critics responded the same way more Eurocentric observers often respond to musical forms like reggae and salsa the first time they hear them: Are they playing the same song over and over again?

The show entranced Gene Smith from beginning to end. In the July 1943 issue of *Popular Photography*, Peter Martin profiled him in an article called "The Kid Who Lived Photography." Martin reported that Smith attended sixty-three consecutive performances of *Mexicana*, obsessed with Marissa Flores and in particular her dancing to the Intermezzo from Enrique Granados's 1915 opera, *Goyescas*, the twenty-sixth of twenty-seven scenes in the show.

Flores and her partner José Fernandez danced the penultimate scenes of both acts. In act 1 they performed a "bulerias" with Gomez on guitar. It's a form of flamenco that allows for the most improvisation and passion, and flamenco performances typically build to it, as act 1 of *Mexicana* did (the final scene of act 1 was a wedding). We can't know exactly what the performance of Flores and Fernandez looked like from Smith's front-row seat, but from Gomez's recorded work we know his guitar would have sounded alert and torrential in small, cascading emotional moments. With Flores's castanets clicking in flamenco's complex, heated rhythms, her black hair in long dual braided ponytails under a scarf, her tan skin, dark eyes, and her native dress whipping and flowing on her fluid dancer's body, she would have made visible Gomez's guitar sounds. She impressed Smith like no woman he had ever seen.

In act 2, Flores and Fernandez essentially closed the show with their performance of the Intermezzo from *Goyescas* (the scene following was a "Finale" with no performers listed in the *Playbill*; it was presumably an encore number with the whole cast onstage). Flores bandied her castanets again, but it was a more classical dance than the raw flamenco bulerias she performed with Fernandez earlier. Rather than backed by the expressive solo guitarist Gomez, this time the dancers were backed by a pit orchestra and the movements were certainly slower and more choreographed, more graceful in a manner that Smith may have appreciated from high school ballroom dancing, but no less emotional. Flores's ability to perform on the two levels must have excited Smith.

According to Martin's 1943 profile in *Popular Photography*, Smith bought a vinyl record containing the Intermezzo and played it repeatedly every night. Along with his memory of Flores, the record may have struck another chord for Smith: that the composer Granados was inspired by the Spanish painter Francisco Goya, of whom Granados wrote, "I am enamored with the psychology of Goya, with his palette, with him, with his muse the Duchess of Alba, with his quarrels, with his models, his loves and flatteries. That whitish pink of the cheeks, contrasting with the blend of black velvet; those subterranean creatures, hands of mother-of-pearl and jasmine resting on jet trinkets, have possessed me." Smith identified with a psychology of contrast like this, and he may have been influenced by Goya's ability to express these contrasts with paint. Smith's eventual war photography, his later work in Spain . . . the threads may extend back to *Mexicana*. But there are more tangible threads that connect Smith's future life to what happened in the Forty-Sixth Street Theater.

Smith attended *Mexicana* with Ilse Stadler, a writer-researcher with Black Star who was still alive when Smith's first biographer,

Jim Hughes, was researching his book in the 1980s. Stadler confirmed that Smith attended the show night after night. She also told Hughes that Smith invited Marissa Flores to a midnight dinner after each show. Flores attended with a singer from the cast who spoke English. The singer fell in love with Smith and she wrote him long love letters in Spanish upon her return to Mexico City. Smith had those letters translated by Carmen Martinez, a Puerto Rican American he connected with through Black Star. Smith eventually married Martinez and they named their first daughter Marissa.

Thirty years later, in the 1969 Aperture monograph financed by his third Guggenheim Fellowship, Smith summarized his *Mexicana* experience this way: "Discovered responsiveness to 'wonderment world of music,' which became and continued as one of several major influences in development of views on ethics, professional integrity, and the creative process." Another major influence, mentioned by him throughout his career, was theater.

For the next seven decades the story of Smith attending these sixty-three consecutive shows has been repeated often, including by me. The trouble is, *Mexicana* was performed only thirty-five times.

WICHITA

On April 30, 1936, a day before his life insurance policy expired, Gene Smith's father drove to a hospital parking lot two miles from their home on the riverbank and blew open his stomach with a shotgun. Suicides made news on a weekly basis in Kansas at the time, sometimes daily, but the brief stories were usually buried in small print in the back of the paper, like classified ads. William Smith's headlines were on the front page above the fold of both daily papers. Seventeen-year-old Gene graduated from high school a month later.

Smith dropped out of Notre Dame and moved to New York to become a full-time professional photographer. Over the next forty years, until his death in 1978, Smith returned to Wichita only a handful of times, and in the voluminous tape recordings from his Sixth Avenue loft, he talks about his father's suicide only once. He called it a "relief," because he could see his father being crushed under the weight of economic and social pressures.

o

Nabokov once wrote that probing his childhood was "the next best thing to probing one's eternity." I can see that. But what about probing someone else's childhood, someone long dead? Rather than my memory or other people's memories (there aren't many alive today who can attest to Smith's childhood in Wichita), I'm probing faint footprints, artifacts, news clippings. Whatever I can find.

In Henry James's preface to *The Aspern Papers*, he refers to a principle I've found pertinent in my years researching Smith: "That odd law," James writes, "which somehow always makes the minimum of valid suggestion serve the man of imagination better than the maximum. The historian, essentially, wants more documents than he can really use; the dramatist only wants more liberties than he can really take." Which one am I—the historian or the dramatist?

During my 2011 visit to Wichita, I followed Smith's trail to the sanctuary of St. Mary's Cathedral, where he had been an altar boy—he attended the Cathedral School through the eleventh grade. I found his tenth-grade 1934 Cathedral School yearbook in a moldy archive room, the lightbulbs burned out. I propped open the door to get enough light, using the flashlight on my phone.

Construction on the cathedral was completed in 1912—the facilities manager told me the majestic sanctuary hadn't changed since. I stood in the back and looked toward the altar. Smith had walked down the center aisle wearing a white robe, carrying lit candles and gold crosses that were several feet taller than him. The natural lighting in the vaulted room was spectacular. Pockets of near-blackness were offset by light streaming through stained-glass windows. The lit spaces were cradled by shadows, creating patterns that directed my eye.

The cathedral sanctuary called to mind the 1933 treatise on

aesthetics *In Praise of Shadows* by the Japanese novelist Jun'ichirō Tanizaki, who wrote, "The quality that we call beauty, however, must always grow from the realities of life, and our ancestors, forced to live in dark rooms, presently came to discover beauty in shadows, ultimately to guide shadows towards beauty's end."

The lighting in the sanctuary unmistakably resembled a vintage Smith print—the African-American nurse-midwife birthing a baby in rural, poverty-stricken South Carolina in 1951, or the mother bathing her deformed child in pollution-ravaged Minamata in 1971. Using his idiosyncratic darkroom shading techniques, Smith visually swaddled and caressed these two caregivers, innocent, he felt, in a way he wasn't. He exalted them, loved them, created odes to them. Another of his most famous photographs is of a woman spinning yarn in his 1951 project "Spanish Village." She, too, is caressed by shadows as she carefully performs her craft.

○

Smith was born in Wichita in 1918. Between 1900 and 1930, Wichita's population grew almost fivefold, from 24,000 to 110,000. It was a pioneer town. With few binding traditions and conventions, anything could happen. People could move there from the farm and take risks. They called it Magic City.

His father owned a grain business and was elected president of Wichita's Board of Trade; his mother, Nettie, was a photographer, and she kept a darkroom in the house. Young Gene started photographing early, and as a teenager he made pictures for the local papers, cruising around town in the family station wagon with the words "W. Eugene Smith, Photographer" painted on the side.

I once stayed in a bed-and-breakfast a block from Smith's childhood homes in the Riverside neighborhood on the bank of

the Arkansas River. It was a quiet, well-to-do suburb in Smith's day. Susan Nelson, mother of the novelist Antonya Nelson, grew up down the street from the Smiths. She described to me a friendly place where nobody locked doors and it was okay to borrow books from neighbors' shelves without asking, as long as you returned them when you were finished.

Smith's first apertures were the windows of his two homes, the first on Woodrow Street and then a larger, second one across Woodrow on North River Boulevard, a block and a half away. Both houses had unobstructed frontal views of the Arkansas River, which is dammed now, but would then have flowed left to right in young Gene's field of vision as he peered over the window-sill, or when he stood on the bank amid the odor of wild onions and the sound of crickets. Both houses faced due east, the sun rising over the river in front.

Two decades later, his dank commercial loft on Sixth Avenue in Manhattan also faced due east. He lived there from 1957 to 1971, longer than anywhere after he left Wichita. He made twenty thousand photographs out the fourth-floor window of that loft, with traffic moving below, a constant flow from both directions (Sixth Avenue was made one-way later). Like in Riverside, people wandered into the loft unannounced. This time thieves and junkies often walked off with his things and pawned them.

o

In 2010, on my first trip to Smith's hometown, there was a tornado warning at three o'clock in the afternoon. For about twenty minutes, the sky turned as dark as night. It poured rain, there was violent thunder and lightning, then, just as quickly, it was all over—daylight glistened on the wet streets. The extreme changes from light to dark to light again resembled Smith's trademark chiaroscuro print shading.

Walker Percy, another Catholic-bred artist, has written that severe weather can make people feel more alive and communal than usual. People secretly enjoy bad storms, he said; the danger can be invigorating, a rallying cry, and offers a connection with others. He also thought the urgency could be an antidote to clinical depression. Smith fed off risk and nerves for the rest of his life, noticeable early with his cavalier photo work in combat zones in the Pacific theater of World War II, and he fell into deep depressions when the urgency wasn't there.

A bipolar pack rat, Smith revered a simplicity he saw in others that he couldn't achieve himself. Sometimes, on his tape recordings, you can hear him talk about the danger of the firetrap loft building in Manhattan burning down, of the relief of losing everything and starting over. But had that happened, I think to myself, what would I have done for the past twenty years?

PART II

3

LIST OF PROJECTS

On Tuesday, February 1, 1955—less than a month after his resignation from *Life*, after a successful and conflicted career—Smith wrote a letter to his mother that began like this:

Dearest Mother:

I am as calm as a sleepy lagoon, although that, and I, may conceal a volcano on the verge of eruption. Who said to you, of the possibilities of my being fired, or of firing. After all it is my eight bucks {owed} against their eight billion {a figurative figure}, and what could be more even than a grain of wheat against the miller's stone—I speak not of mill stones dangling from a chain around my neck. Shed no tears of compassion for only tragedy awaits—but as yet it awaits not for me. It may be that we are walking hand in hand, tragedy and I, and desperation makes three. Though my stomach quivers like a professional belly dancer, the dancer is paid and mine is caustic{ing}. All is not lost, instead, I have thrown it away, lightly, dancingly, trippingly away—though I calculate it may return as would a friendly boom-a-rang, and if it doesn't, let me rest six months to lift the rubble of collapse from about my head.

In other words, don't get perturbed—difficulty, but not destruction is at hand. And everyone shall get their money as well.

It's unclear if Nettie Smith ever saw this letter. On Sunday, February 6, she collapsed and died in Wichita, after attending morning mass at her beloved St. Mary's Cathedral. She was sixty-five and had been sick, in and out of the hospital. Her son's letter might have reached her mailbox before she died, or a day or two later.

On Tuesday, February 8, Smith flew from New York to Wichita for the funeral arrangements. He returned to New York a few days later, leaving the house cleanup and estate work to his brother, Paul, and his uncle Jesse Caplinger, his mother's brother.

o

Smith was thirty-six years old and in his prime. He joined the prestigious photographers' cooperative Magnum, through which he would seek freelance assignments. Freed from a dozen years of pent-up frustrations at *Life*, a photographic eruption was inevitable.

On March 25, 1955, he wrote Magnum's executive editor, John G. Morris, an eight-page single-spaced letter in which he listed seventy-three prospective topics for photo-essays. He made no mention of his mother's recent passing. Smith wrote (syntax and spelling are his):

Dear John: From the top of me hat, and the bottom of me bottles bottom, are some of the ideas—edited and unedited, that have tripped upon my loggy brain, and have had at least a bit of squintin at for size, creativeness, and taste. But as I say, this list as presented here is not necessarily a sure thing of my accep-

tance, for several of them would certainly have to be examined far more carefully for potential, and compatibility. I send this list to you far more for the purpose of letting you know how my mind sometimes wanders—and though it contains many of the stories I have suggested to Life (and I will indicate most of these), it is not a list that I would present in this fashion to any editor. I am, as well, too damn tired tonight to try a spruce-up job on it—or you would receive it in a more precise, and careful style.

Smith's list contains subjects and themes reverberating backward and forward throughout his life and career, offering glimpses of his feverish artistic desires at a pivotal time. No other document or oral history provides access to Smith's ambitions and state of mind in a form as raw and unmitigated as this list.

The first thirteen entries on Smith's list are indicative of the whole:

1. Preservation of camps to contain those judged as subversive when it is decisioned that dire emergency exists . . . I thought this aspect of the Justice Department's program worth investigating.

2. The Hutterites: The 8500 Hutterites of this hemisphere live in ninety-one colonies in the Northwestern United States and Canada. They live their own way of life, apparently without need, or acceptance of the incentives motivating much of the world, and motivating even their immediate neighbors, yet they are close to the mainstream of America, and have daily business and social contact with the "world." The Hutterites insistence upon simplicity of living conditions is based upon the belief that wealth, personal power, and artistic adornments are sinful objectives.

3. Basic research: . . . this would be a long one and a tough one because it takes understanding of a very complicated branch of science. It is (on the surface) unphotographic as nearly a blank wall—and it is a story and a problem of extreme importance.

4. A man and a castle: being built by the one man, somewhere in California, he has been working on it six years at least.

5. Man who has chosen a life of contemplation: . . . It is photographically difficult, almost impossible, yet with time, and care, and understanding—and a profound marriage of words to photographs, this could be magnificent. Again, it is vaguely of the idea stage.

6. An orphanage: lonely men, and castle builders, brought me to thinking there would be potential in this.

7. Commuter's route: . . . The route I chose would be New York to Poughkeepsie, although it could have a wonderful variety from Croton on in. The only restriction (after eliminating the doing it from the train) would be that the subject could be seen from the tracks.

8. Broadway, from the beginning to its Albany end.

9. R.R. Station: a portfolio, or essay: . . . to hang around a small station for a couple of weeks, letting it be the hub, with all of the activity of the story coming to it—preferably a station, perhaps southwest, where cattlemen, military school, Indians, dudes, traveling salesmen, etc., although it need not be as garish as that listing might sound.

10. Satirical story of children and toys—the weapons and passions we give our children, utilizing the toys that are the weapons of hate and murder.

11. Men of 80, a Portfolio. . . . People that were still functioning, with importance.

12. The Japanese movie industry, an essay.

13. Back lots of Hollywood, a portfolio, the surrealism, photographically speaking, of the back lot storage spaces.

In these entries we can see Smith focusing on the human landscape and the tension he felt between isolation and the teeming churn of collectives, a tension he never reconciled, and many themes of home—creating or finding a home, leaving and returning home. There is also cinema, an effort to make and present a world, a craft perhaps more flexible than his chosen one though also more collaborative, which would have thwarted him.

After the thirteenth entry, Smith inserted the following note to Morris:

By now one thing may be slightly evident; to a certain degree I am veering from stories that present the nerve draining, emotionally twisting stories that are of intense involvement on every level of approach. I am trying to spare myself enough in the face of other problems, to let my nerves settle, my depression lift, and a little resiliency is once more evident in this dragging hulk. HOWEVER, let the project really present itself that can really intrigue and seduce my mind and soul, and I'll throw the body into the deal—and it will respond, perhaps aided by a little

*Benzedrine. Remember, don't hesitate in thinking I would ac-
cept such a project . . .*

In his final letter to his mother, Smith recognized he was boiling
over. Whether it would be one of these seventy-three subjects or
something else, he was about to "throw" himself into a project
on a scale bigger than anything he had ever done. He only needed
a starting point.

4

JIM KARALES

In early March 1955, Gene Smith steered his overstuffed station wagon into the steel city of Pittsburgh. He'd been on the road all day, leaving that morning from Croton-on-Hudson, New York, where he lived in a large, comfortable home with his wife and four children, plus a live-in housekeeper and her daughter. Through Magnum, Smith was hired by the renowned filmmaker and editor Stefan Lorant to shoot a hundred scripted photographs for a book commemorating Pittsburgh's bicentennial, a job Lorant expected to take three weeks. On Smith's horizon, however, was one of the most ambitious projects in the history of photography. His station wagon was packed with twenty-some pieces of luggage, a phonograph, and hundreds of books and vinyl records—he was prepared to stay much longer than three weeks.

A hundred and eighty miles southwest of Pittsburgh, in Athens, Ohio, James Karales was finishing up a degree in photography at Ohio University. He had studied Smith's work in class; Smith was a hero. While Smith was crawling all over Pittsburgh, day and night, several cameras wrapped around his neck, fueled by

amphetamines, alcohol, and quixotic fevers, Karales was getting his diploma. Little did Karales know, his path and Smith's were about to overlap.

Smith returned to Croton in late August with about eleven thousand negatives from Pittsburgh, intent on making a photo-essay to end all photo-essays. Lorant was livid. Where were the hundred scripted photos he had hired Smith to make? Lorant pressured Magnum, but Smith wouldn't release anything. He was paranoid that Lorant would try to take ownership of his intended masterwork. Eventually Smith sought and obtained a copyright from the Library of Congress to protect himself.

Meanwhile, Karales, fresh out of school, moved to New York to seek work as a professional photographer. He knocked on Magnum's door and asked John Morris whether there was any work for a young photographer. *Do you want to be Gene Smith's dark-room assistant?* Morris replied.

Karales took a train to Croton that same day and moved into one of the Smith family's guest bedrooms. There were now four adults and five children living under one roof, and one of the adults was a man possessed. It was like asking a new film-school graduate to help Francis Ford Coppola complete *Apocalypse Now*, a project that almost killed the director and alienated everybody around him.

o

Forty years later I visited Karales, who was still living in Croton, now with his wife, Monica. In the interim years he had become a world-class photojournalist and a staff photographer for *Look* magazine, producing some of the most iconic photographs of the civil rights era and the Vietnam War as well as powerful por-traits of the Lower East Side and the small town of Rendville, Ohio, among others.

Karales drove me around town and showed me the former

Smith property on Old Post Road, a sprawling two-story house made of stone with a matching stone wall around the perimeter of the spacious, leafy yard. He mused on his experience while my tape recorder ran.

Gene thought I was an idiot when I first met him, said Karales, chuckling. *I told him I'd just graduated from Ohio University. He thought I hadn't gone through the sixth grade! But I was pretty naive. I came from an immigrant family {his parents were Greek}, and I didn't read much. And here I am, up there with this bloody genius. It just opened my life up completely. The reason he was nice to me is he needed me. Thank God that relationship existed, because, otherwise, shit, I'd have been living down on the street someplace.*

Smith went back to Pittsburgh and exposed another ten thousand negatives, bringing the total to twenty-one thousand. Karales stayed in Croton and made prints. Smith considered two thousand negatives to be valid for his opus, an impossible number given his laborious printing techniques. Certain prints required a few days to make, said Karales. The pair made dozens of 5 x 7 work prints for each negative, testing and experimenting until Smith was satisfied. Then they would make an 11 x 14 master print. They did this for three years, eventually bringing around seven hundred of the images into master print form, a herculean accomplishment, though still far less than Smith desired.

We went through a lot of {emulsion} paper, Karales remembered, *because Gene didn't do what you'd call a script. A script didn't mean anything to him, not when he was shooting or when he was printing. He wanted to see the whole thing, and see what areas needed to be worked on as he was going along. We went through boxes of paper, believe me. We bought two hundred and fifty sheets at a time. Before this, I never knew what you could do in a darkroom. At least fifty percent of the image is done in the darkroom—I think Gene would say ninety percent. The negative has the image, but it can't produce the image completely, as the photographer saw it—not as Gene saw it. You have to work it over and*

over with the enlarger, you have to burn it in, you have to hold back areas—this detail down here or over there.

Gene always liked to get separations around people, figures, and that was always done with potassium ferricyanide. It was the contrast that made the prints difficult. Gene saw the contrast with his eyes, but the negative wouldn't capture it the same way. So he would have to bring the lamp (light) down and burn, and then if that spilled too much exposure and made it too dark, you would lighten it with the ferricyanide. You had to be careful not to get the ferricyanide too strong, and yet you couldn't have it too weak, either. If it took too long {to work}, it {i.e., the effect} would spread. So I would blow the fixer off of the paper so {that} ferricyanide would stay in an area, and then dunk the paper right away {in a tray of fixer} to kill the action {of the ferricyanide}. Or if you wanted something to go smoother, then you left the fixer there. It was extremely delicate and complicated, but we got it down pat.

Karales drove me back to his home in Croton and we took chairs at the dining room table to continue our conversation. His wife, Monica, in her seventies at the time, walked back and forth through the room wearing a skimpy yellow bikini (she'd been sunbathing in the backyard). *Monica, put on some goddamned clothes!* he said, laughing.

Several years later I talked to Smith's son, Pat, who was thirteen years old when Karales moved into the family home, and he told me: *Jim, he was a good guy. He and my father used to get in big fights, because Jim saw what was going on, how the family was being neglected by my father, and he used to holler at him to straighten up. My father would then argue back and forth, saying he had his commitments to honor, you know, that sort of thing.*

Smith gave up a large salary and expense account when he left *Life*. The family was destitute; tensions in the house grew. Smith and Karales worked while the family slept. *We'd usually get up around two, three o'clock in the afternoon,* said Karales, *have lunch,*

and start printing. Then the family would go to bed, and when they got up, we went to bed.

Karales described to me how Smith arranged Pittsburgh layouts all over the Croton house. *He first started in the dining area, and when he ran out of room, we had to go into the living room area. He bought eight-foot-by-five-foot panels—bulletin boards that stood on legs, so you got both sides. And then all these five-by-sevens would be pinned up there, and he would look at them and study them and make sure which ones he wanted in his essay. And then we would make the prints, the final eleven-by-fourteen prints.*

Gene believed you can have a picture that's really powerful, but if it doesn't fit within the layout, in the storytelling situation, then you don't use that picture. One time, after I got the job at Look, *he laid one of my stories out for me, the Selma March stuff, before I showed it to the magazine. In* Look, *the art director used my iconic Selma picture first. Gene used it in the middle somewhere, which would have made more sense. It was amazing what he did with the pictures, with their sequential situation. Gene got me that job at* Look, *by the way. I think that was my payment for helping him. He never paid me in money.*

Smith finally answered his obligation to Lorant, but his Pittsburgh magnum opus fizzled in an erratic layout he published in *Popular Photography*'s Photography Annual in late 1958. In a letter to Ansel Adams, he called it a "debacle" and a "failure." Smith left the family and retreated to the flower-district loft. Karales lived for another two years in the Smith house before finding his own place in Croton.

A significant legacy of Smith's Pittsburgh project was the apprenticeship of the young Karales. He came from the last generation of photographers whose childhood and youth were not informed by the takeover of television, when printed pictures served as culture's primary visual imagery. A modest, unassuming man until his passing, Karales never climbed the ladder of fame, didn't

seem to care about it. He just did his job. His ethic and personality seemed more like that of a carpenter or refrigerator repairman than a gallery-hopping artist, making him perfect for the job with Smith—*just put your head down and make prints, pal, and make them like this.* For the rest of his career, Karales displayed a profound, velvety darkroom printing technique reminiscent of Smith's. Karales, though, wasn't trying to change the world. Maybe Smith could have learned a little something from him.

PART III

5

THE BIG BOOK

On September 2, 1958, Gene Smith's passport was stamped in Geneva, Switzerland. He had been hired by General Dynamics to photograph the United Nations International Conference on Peaceful Uses of Atomic Energy, known as "Atoms for Peace." He was to be paid $2,500 for two weeks of work, plus a $280 per diem. Commercial work wasn't Smith's preference, but he needed the money. He needed some distance from New York, too.

A week later, on September 9, Smith's long-awaited extended essay on the city of Pittsburgh hit newsstands. He had staked his reputation on the work. Two consecutive Guggenheim Fellowships (the first one coinciding with Robert Frank's fellowship for the work that became *The Americans*) further raised expectations. After Smith turned down $20,000 from both *Life* and *Look* magazines when they would not agree to his demands for editorial control, *Popular Photography* offered to put thirty-six pages of their 1959 annual at his disposal for $3,500. Smith accepted.

Now the anticipated magnum opus was set to arrive. But rather than stick around to toast his achievement, Smith jetted to Geneva. He had anticipated a Pittsburgh flameout earlier that

summer, in a letter to his uncle Jesse Caplinger: "The seemingly eternal, certainly infernal Pittsburgh project—the sagging, losing effort to make the first of its publication forms so right in measure to the standards I had set for it."

Less than a week after the annual appeared, the influential photographer and editor Minor White wrote a letter to John Morris at Magnum to complain about the waste of prime space given to the Pittsburgh spread. "Gene doesn't have proper training in layout," White wrote. Jacob Deschin, writing in *The New York Times*, was more charitable, calling the Pittsburgh essay a "personal triumph" for Smith and an "intensely personalized, deeply felt document." He wrote, "Mr. Smith uses layout as an additional means of communicating his impressions of the city's varied facets, its human and physical qualities . . . The approach is poetic, evoking the city's character, the atmosphere of its everyday life, recalling the past and pointing up some of the bright signs of the future."

But Deschin also cited the spread's challenges: "Some readers may object to the details of the layout, such as the use of small pictures, rather than fewer and larger." Smith had crammed eighty-eight images into thirty-six pages, along with a not insignificant amount of text. Additionally, the trim size of the Photography Annual was 8.5 x 11, compared with 11 x 14 at *Life*, where he had spent the last twelve years. His desire for meditative visual sequences had outstripped the available format.

Two years earlier in Pittsburgh, Smith had met a young avant-garde filmmaker named Stan Brakhage, who had been hired to make a film commemorating the city's bicentennial. The two artists hit it off. Each admired the other's dedication and belief in the power of seeing, which, they both thought, was so often tainted by commercial pressures, popular culture, and human fears. Brakhage used Smith's stills in his cut of the film (a cut

never released and unavailable today; another director finished the film), and his cinematic philosophies spurred new ideas for Smith's Pittsburgh layouts.

○ ·

In Geneva, Smith shared a chalet with Brakhage, who was also there to document "Atoms for Peace." They attended the conference by day and shared scotch and conversation by night. Smith craved the fertile, boundless, uncompromising engagement offered by twenty-five-year-old Brakhage, who in 1958 had completed the film *Anticipation of the Night*, which he'd considered ending with the scene of his own suicide, a thought that I imagine would have thrilled Smith.

The true impact of the relationship between Smith and Brakhage, though, can only be speculated. In June 2003, I was at a café in Santa Monica with Carole Thomas, Smith's girl-friend with whom he shared his Sixth Avenue loft from 1959 to 1968. *Gene was obsessed with this avant-garde filmmaker who used to come over to the loft*, she told me, but she couldn't remember his name.

A few years later, my colleague Dan Partridge found several minutes of recorded sound among Smith's loft tapes, in which Smith can be heard reading from a 1963 writing by Brakhage: *How many colors are there in a field of grass to the crawling baby unaware of "Green"?* I called Carole Thomas. She confirmed that the filmmaker she couldn't remember before was indeed Brakhage. I reached out to Brakhage's first wife, Jane Wodening, and to his widow, Marilyn Brakhage, both of whom confirmed the friend-ship between Smith and Brakhage but could not recall much else. Years passed. I moved on to other areas of research. Then, in 2014, a May 1970 letter from Brakhage to Smith was found in the Brakhage archive in Boulder, Colorado, then the original in

the Smith archive in Tucson. It was signed only "Stan" and is mostly a rave about Smith's 1969 Aperture monograph. The letter included this line:

> *Wonderful how clearly your face comes to me the instant I type your name—your face . . . its particular intensity: and then I have a shift of backgrounds including the kitchen in that damn Swiss chalet, the nightmarish Atoms For Peace circus, and then most happily your loft in N.Y.—your face remaining a constant thru all this, weathering these scenes with an etch of grace: see, I've almost got a motion picture portrait out of these memories.*

Smith returned from Switzerland embarrassed by Pittsburgh but emboldened to go even further with his ideas for sequencing still images. He embarked on a two-volume, 350-page retrospective book that eventually contained 450 photographs spanning his career to that point. It became known, properly, as *The Big Book*. It could also have been called *The Unpublishable Book*. The dummy or maquette existed only in Smith's archive until an extraordinary facsimile of it was published in 2013 by the University of Texas Press and Smith's archive in Arizona.

o

Brakhage felt that words deadened the senses; the majority of his films are silent.

In his 1982 talk "Impossible Stories," the filmmaker Wim Wenders says, "In the relationship between story and image, I see the story as a kind of vampire trying to suck all the blood from an image. Images are acutely sensitive; like snails they shrink back when you touch their horns. They don't have it in them to be the cart horses, carrying and transporting messages or signifi-

cance or intention or a moral. But that's precisely what a story wants from them."

Wenders's concern for the image helped me articulate my evolving feelings about Smith over the twenty years I have been studying his life and work. When Smith resigned from *Life* in early 1955, he also gave up journalism once and for all. In Pittsburgh, Brakhage's silent films impressed Smith. His work moved further beyond journalism than ever, further beyond story, toward image and poetry. But he couldn't shake the need for story in his public presentation. As a result, he strangled his extraordinary, lyrical Pittsburgh images with sentences. In one section comparing the most exclusive private club in Pittsburgh to a union beer joint, he added these words: "Yet at the core, down at the coiling depths of pulse and instinct, what difference here except in furnishing?" I want to shake Smith. Hey, man, just let the images breathe.

In contrast, *The Big Book* contains no text. It opens with tender pictures of children, including Smith's own, and closes with brutal images of carnage on the front lines of World War II. In between there are some two dozen of his iconic images from *Life*, and many more that are rarely, if ever, published in Smith monographs, including some of the most abstract and ephemeral work of his career, all woven together with no concern for chronology, subject, or theme. Images from "Country Doctor" and "Nurse Midwife," for example, aren't confined to discrete sections. Journalism was thrown out the window. There was also no concern for making commodities of individual photographs, a growing trend in the art world at that time. What matters most in *The Big Book* are shapes and rhythms, patterns of tones, and an underlying sense of the foibles of human culture—the hungry, blind march toward death, often at the political and economic hands of fellow humans. These are all ideas Smith and Brakhage would

have discussed during those long nights in the Swiss chalet. *The Big Book* represents Smith's most fully formed ideas for layout. Unrestrained by the strictures of print journalism, rejuvenated by Brakhage, Smith produced what would be the pinnacle of his sequential aesthetic.

In addition to Brakhage, *The Big Book* achievement owes much to Carole Thomas, who wandered into Smith's life as a soft-spoken, eager, and brilliant art student in 1959 and stayed for nine years. Only eighteen years old, she already had a background in theater design, which made her the perfect partner for Smith, who often claimed theater was his most important influence, not photography. Thomas adopted Smith's dedication to *The Big Book*. She became the thoughtful sounding board he needed in order to finish projects at this stage in his life. Her aptitude can be heard in darkroom conversations recorded on Smith's tapes. She also became a masterful darkroom printer in her own right. Thomas was integral to Smith's achieving the most audacious product of his career. It would be her unseen opus, too.

6

LARRY CLARK

In October 2011, I received an e-mail from the photographer Larry Clark. I knew something of Clark's relationship with Smith because Clark had written about it briefly in his essay in the anthology *Darkroom* (Lustrum, 1977). Smith's printing techniques influenced him and he used two variants of his portrait of Smith to illustrate his essay. But that's all I knew. Clark and I talked on the phone a few days later, and he told me this story:

I remember I came into town and went up to his loft and just rang the bell and I told him I was, you know, a photographer and I had these pictures that I'd like him to see. He was at the top of the stairs. These stairs went way up and he was standing at the top with his head leaning against the wall, cupping his head in his hand. He said, Oh, I've been in the darkroom without any sleep for a week, you know, or something, I'm so tired I can hardly stand up, you know, which is probably true because he used to go into the darkroom for long periods of time and drink scotch and print and listen to music. He said, I just don't have time. He said, Well, if you leave them, maybe I'll get a chance to look at them. So I guess I walked up the stairs and put them at his feet, probably, and left. They were all the early Tulsa pictures. I got back to where

I was staying a couple of hours later and he had called and left a message. So I called him and he said, Get your ass over here. So I went over. He wanted to know, What the fuck was this? What is this? You know, all these kids shooting drugs. He'd never seen anything like it. So we got to be friends. I went over to see him a few times and we would talk. Kind of the price of admission was I'd bring a bottle of scotch over. We'd drink warm scotch out of paper cups. He was a very good guy, a very good guy.

A few days later, Clark sent me an extraordinary photograph of one of his meetings with Smith inside the loft. He thinks it was taken in 1962 or 1963; he was about nineteen, and he'd just hitchhiked to New York from Milwaukee with the photographer Gernot Newman, who snapped the picture. Clark is dressed in a suit and tie and sits hunched, camera in hand, at Smith's feet. Smith is reclined in a suggestive position: one arm behind his head and a bulge in his pants. Perhaps the bulge was a coincidence, simply a gathering of loose fabric. In any case, the metaphoric value is appropriate. At this point in Smith's life—around age forty-four, several years departed from *Life*, with his list of failed major projects growing—he adored playing the part of master to young aspirants and he sought it for energy. He wasn't getting the same public affirmation he once had at *Life*. The legendary maverick had bucked mainstream conventions and prosperity by leaving the corporate magazine, protecting what he called in a letter to Elia Kazan "the Smith standard." But the standard also required a lot of affection and it often came in the form of pilgrimages to his loft—*come to my feet, little novices, and bring me a bottle of scotch.*

CAMINO REAL

Around December 1966, at age forty-eight, Smith was down and out. He drank a fifth of scotch and ate countless amphetamines every day. At this point, his live-in girlfriend of seven years, Carole Thomas, was loyal but growing weary. He maintained grand, alluring ambitions, but nobody would hire him for fear of igniting an impossible odyssey. The underworld jazz scene in the building had fizzled out two years earlier.

Nothing in particular was happening on this winter evening, but Smith rolled his tape recorder for seven hours anyway. He caught WBAI radio news stories on Vietnam, atomic bomb fears and backyard shelters, civil rights, and urban drug problems. There was a literary program on Hemingway in Cuba, something about Kafka, and a reading of a Katherine Anne Porter short story. Smith was walking around the loft wearing an eyeball-shaped crystal on a chain around his neck. The following bit of conversation was caught on tape:

Thomas: *Where did you buy that perceptual eye? I want one.*
Smith: *From a gypsy. She was wearing it around her neck.*
Thomas: *Would you get me one?*

Smith: *I have to find a gypsy first. Actually, it was the eye of her daughter. It had a tear in it. It took a year and a half for her to build a tear. When she had an emotion, which wasn't often, she would take this eye and she would squeeze it. And one tear would drop out, and because it was so rare, so precious in this callous little witch, it became like a precious stone, a jewel of a tear. And kings fought mighty battles and killed millions to gain this precious stone.*

Thomas: *Is this another one of your stories?*

Smith: *{Laughs.} Well, no. Let's say I stole it from Tennessee Williams, his great play* Camino Real, *in which—in one of the most beautiful moments I've ever seen onstage—she, the gypsy's daughter, kneels alone on the stage and suddenly she says, "Look, Mama, a tear." And it seemed, beyond the whole idea of all existence, that somehow, she, the conniving rotten little mother-taught daughter, produced a real honest-to-goodness glittering tear. It was a very beautiful moment. As a matter of fact, I think someday somebody's gonna revive that play and they're going to learn that it's one of the greatest plays of American theater. It certainly was one of the most exciting evenings that I ever spent in the theater.*

That's saying a lot. Smith spent many evenings in the theater, for fun and for work. In 1947, he followed Williams around and photographed the rehearsals and premiere of *A Streetcar Named Desire* for *Life*. He made an intimate portrait of Williams doing the backstroke in a pool at the New Orleans Athletic Club, apparently nude with an erection. He tape-recorded TV and radio performances of several Williams plays, including *The Fugitive Kind*, *The Yellow Bird*, and a 1960 performance of *Camino Real*. He even taped a 1960 Edward R. Murrow program featuring Williams and the Japanese writer Yukio Mishima in conversation. It was Williams's blend of documentary naturalism, elements of fantasy, and his mix of tenderness and destruction, vitality and despair, that Smith tried to emulate in his photography.

Not many people, even theater professionals, have seen a production of *Camino Real*, not to mention a good one, and few feel as strongly about it as Smith did. He saw the play's 1953 debut, directed by Elia Kazan, which was drubbed by critics. It hasn't been revived on Broadway since 1970. A New Directions paperback of the script, with a powerful introduction by John Guare, reprints the original *Playbill* notes, in which Williams states the play "is not words on paper." "Of all the works I have written," he argues, "this one was meant most for the vulgarity of performance."

In an effort to learn what Smith saw in *Camino Real*, I called Ethan Hawke, who played the play's protagonist, Kilroy, in a revival at the Williamstown Theater Festival in 1999, a production mentioned in the theater world as the definitive treatment of that play. Hope Davis played the part of the gypsy's daughter. Hawke was eager to discuss it:

I can see why Smith liked it. The play is almost impossible to get right—it's a balancing act of tones—but it can be done. It can shatter people. In many interpretations of it, Kilroy has died of a fever, and the play is his dream before death, an imagined purgatory, a place where everything we thought was important (class, poetry, money, sex, politics, violence) is a crass joke. The place is hot and sweaty, and everything is dirty and dilapidated. Images are all that matters. They streak across the stage one after another, like a comet blazing across the atmosphere. It's like T. S. Eliot wrapped in a vaudeville act. There is something terribly sophisticated happening simultaneously with something ridiculously sexy and silly. Imagine Prufrock in a strip club, with naked women wrapped around silver poles while drunk fat men claw at their wallets. The scene with Kilroy and the gypsy's daughter is the most electric minutes I've ever spent onstage. Hope Davis was tremendous, like Judy Holliday with a streak of wisdom. The scene's like a live sex show, with no clothes coming off, if a live sex show could make you laugh and cry. It's

a lightning bolt. I do not hyperbolize. It's Tennessee at the full reach of his powers.

The way Hawke talks about *Camino Real* is not unlike the way I have talked about Smith and his loft over the years: feverish, dreamlike, hot, sweaty, dirty, dilapidated, sexy, silly, electric, comic, tragic, a balancing act of tones. The play is about derelicts, misfits, outcasts, and romantic dreamers who are struggling to avoid the street cleaners (literally) of the conventional, educated world. These are the same people that were hanging out in the Sixth Avenue loft. Some of them played piano, drums, or saxophone; others helped him organize his mess.

Camino Real is usually depicted as a flight of fantasy for Williams, a departure from the natural realism of *Streetcar*, *The Glass Menagerie*, and *Cat on a Hot Tin Roof.* I called the Target Margin Theater's artistic director, David Herskovits, to ask him about it. He's studied the play for years, including correspondence between Williams and Kazan and their stage notes, and he's produced and directed a one-act version, *Ten Blocks on the Camino Real*, and another play, *The Really Big Once*, based on the Williams-Kazan collaboration on the original. *I don't see* Camino Real *as a departure for Williams at all*, Herskovits said. *He was constantly experimenting. There is a poetic, dreamlike quality underneath the surface of everything he did, even pieces like* Streetcar *and* Menagerie. *It does buck the trends of its time, though. After the war the naturalistic methods swept the field of American theater for a while.* Camino Real's *dramatic language is more musical than narrative. The image itself is eloquent. The image grabs your attention in an associative, unconsoled, and mysterious way, not a narrative way. That play influenced a lot of important people in 1953. I know Sidney Lumet saw it and was still talking about it a half century later.*

In *Camino Real*, the mythical character of the poet Lord Byron makes an appearance and delivers a soliloquy in which he says,

"For what is the heart but a sort of—a sort of—instrument—
that translates noise into music, chaos into order—a mysterious
order. That was my vocation once upon a time, before it was ob-
scured by vulgar plaudits! Little by little it was lost among gon-
dolas and palazzos!" Then he declares, "Make voyages! Attempt
them! There's nothing else."

SEAN O'CASEY

On August 15, 1965, Smith was up late, as usual, in his dingy loft space, working on the first issue of *Sensorium*, his new "magazine of photography and other arts of communication," a hopeful platform free of commercial expectations and pressures. He was editing a submission by the writer E. G. "Red" Valens, whom he had met in 1945 when both were war correspondents in the Pacific. Despite the late hour, Smith decided to give his old friend a call.

Valens's wife answered the phone just before the fifth ring. She'd been asleep. She gave the phone to her husband. He'd been asleep, too.

Good morning, said a groggy Valens.

You don't stay up as late as you used to, joked Smith.

He then apologized for calling so late. Valens wasn't irritated. He even resisted Smith's offer to call back at a more reasonable hour. Thirty-six minutes and nineteen seconds later, the pair said goodbye and hung up. Smith recorded the call.

After the discussion of Valens's article concluded, the conversation turned to the habit of taking notes while reading. Smith

said he couldn't read one page of Henry Miller without taking three pages of dissenting notes. Valens said he could rank his library based on the number of notes he'd jotted in the margins of each book—the more notes, the more favor. Smith responded by expressing adulation for an Irish writer who had passed away the previous year:

That seeing, thoughtful soul Sean O'Casey causes me to be . . . when I run out of imagination or I'm just dead against a wall—I can't function, I can't think right, I have no probe, if I read O'Casey for a little while . . . I'm usually back to seeing and searching, and things start pouring out. Very few writers can do that to me. Faulkner can do it to some extent. O'Casey is my old standby. I always include a copy of O'Casey when I go somewhere on a story.

Valens then said, *That's worth a short article next time you run out of ideas for an issue {of* Sensorium}—"O'Casey: The Traveling Man's Boon."

Smith chuckled.

Valens then said, *No, I'm serious.*

Three weeks later, Smith's financing for *Sensorium* fell through and another grand ambition was left unfinished. An essay treatment of O'Casey's impact on Smith's photography never emerged, either.

This twenty-second comment by Smith about Sean O'Casey, in a dubiously recorded, nocturnal phone call in August 1965, led me down a rabbit hole. There are other references to O'Casey in the Smith annals, but none this intriguing to me.

o

In a letter to two editors at *Holiday* magazine in 1957, while pitching a layout of his extended work-in-progress on Pittsburgh, Smith described the intended opus as "Tennessee O'Neill or Wolfe O'Casey." The four names refer to three playwrights and a

novelist, Thomas Wolfe, who also wrote several one-act plays. Throughout his life, Smith referred to literature and theater (and to music) as the most important influences on his photography, but he rarely provided references to specific works.

Smith's obsession with theater registered in other ways, too. Of course, his first daughter, Marissa, was named for a dancer he met while photographing *Mexicana* in 1939. In much of his classic *Life* work, especially 1948's "Country Doctor," his pictures resemble theater stills. He photographed the preparations and openings for original productions, such as *Death of a Salesman* and *A Streetcar Named Desire*, and he produced two major photo spreads on obscure theater subjects for *Life*. When he began making voluminous photographs out his fourth-floor window in the late '50s, he called the frame his "proscenium arch."

Smith spoke of his photography assignments as "stories," as he did in the phone call with Valens. He would have been closer to the truth if he'd said, I always include a copy of O'Casey when I go somewhere on a *poem*. He never recognized or reconciled the difference between story and poem, or journalism and art, and the tension troubled him.

○

When Smith's archive was bequeathed to the University of Arizona, among his library of 3,750 books were two collections of Sean O'Casey's plays, five of the six volumes of his autobiography, one essay collection, and two individual plays, *Cock-a-Doodle Dandy* and *Red Roses for Me*. Who knows how many O'Casey volumes Smith lost or gave away or were stolen from the Sixth Avenue loft?

Also, among Smith's 25,000 vinyl records was much of the spoken-word catalog of Caedmon Records, which means that it can reasonably be assumed that he owned that label's 1952 re-

cording of O'Casey reading selections from *Juno and the Paycock* and from two of the autobiographies.

According to Smith's first biographer, Jim Hughes, Smith had an affair with a young actress who read O'Casey aloud to him in 1949. Six of the books by O'Casey that Smith owned were published between 1944 and 1949, and thus would have been available during the affair. O'Casey had died less than a year before Smith's 1965 taped phone call with Valens, and *The New York Times* ran a two-thousand-word obituary. There was even a Hollywood movie—*Young Cassidy*, from MGM—based on O'Casey's autobiography that had been released earlier in 1965. The playwright reverberated in the culture far more than he does today.

But what if Smith was more or less bullshitting about O'Casey, slightly eager to impress in that lonely, sad-hour phone call? What if, knowing his tape was rolling, Smith had enough ego to imagine a researcher would one day be listening?

PART IV

CHUCK-WILL'S-WIDOW

During the wee early morning hours of September 25, 1961, two African-American jazz pianists, Walter Davis Jr. and Frank Hewitt, walked up Sixth Avenue toward Twenty-eighth Street. In the center of Manhattan, the neighborhood was shut down and desolate. The flower district's sidewalk storefronts kept daylight hours and commercial zones prohibited upstairs residency. The sleepy Sixth Avenue bus scattered stray hot dog wrappers, cigarette butts, and paper cups under the streetlamps. Davis and Hewitt crossed Twenty-eighth Street and stopped in front of a five-floor brick-and-plank loft structure that dated to 1853. One of them whistled the call of a chuck-will's-widow, a nocturnal, ground-dwelling swamp bird kin to the whippoorwill.

The door of 821 Sixth Avenue was often open. Sometimes there was no door at all, just a dark, open stairwell shaft. Those unaccustomed to the loft—midtown magazine editors and downtown art impresarios—were afraid of it. Davis and Hewitt were dropping by to see if there was a jam session.

On this night a door was installed and it was locked. The temperature had reached over seventy degrees earlier in the day, over ninety degrees on other days that week. The windows

upstairs were wide open. The sidewalk whistle was a signal to somebody—anybody—to drop a key down so Davis and Hewitt could let themselves in. Smith was forty-two and living on the fourth floor of the building. He had wires running like veins through walls and floors, connected to microphones on one end and a reel-to-reel tape machine in his darkroom on the other end. He recorded the comings and goings all night. His mics caught the mimicked chuck-will's-widow around 2:00 a.m.

o

Forty-seven years later, in 2008, I was listening through headphones to this particular recording one night in my home in North Carolina. I was jerked to attention by the recorded birdcall. What was that? Reverse fifteen seconds, play. Reverse, play. Reverse, play.

The chuck-will's-widow spends summers in the wooded swamps of the American South and winters in northern South America and the Caribbean. Its call is a click or "chuck" followed by two quick boomeranging loops, an intricate, siren-like melody. Only a practiced whistler familiar with the sound could mimic it. The birdcall was familiar to me, from my life on the shores of the Pamlico River in North Carolina's rural coastal plains, where I grew up in the 1970s and where I still spend a lot of time today.

Hewitt was born in New York to parents from Trinidad. Davis was from Richmond, Virginia. Either man could have whistled the chuck-will's-widow call, but I believe it was Davis, who later in his life said he saw the ghost of the dead Thelonious Monk walk into his recording studio. It would be like Davis to value, practice, and preserve a birdcall from his childhood on the James River, in the same manner that he preserved Southern gospel and blues traditions in his jazz.

What still puzzles me about this tape, though, is that Smith recognized the birdcall instantly. He was on the fifth floor of the building, disassembling microphones and cords he had installed to catch jazz jam sessions that could happen there on any night and early morning. He was storing his equipment in preparation for his absence; the next afternoon he would fly to Japan from Idlewild Airport (now JFK). He left one microphone live, connected by wire to his tape machine a floor below. After hearing the whistle, Smith recorded himself on tape, mumbling, *Frank, there's a chuck-will's-widow out there.*

"Frank" was Frank Amoss, a young jazz drummer who had moved into a space on the fifth floor of the building earlier in the summer.

Amoss responded, *Oh, somebody's out there?* He walked to the window, leaned out and looked down to the sidewalk, recognized Davis and Hewitt, said hello, and told them there weren't any jam sessions happening that night. *Forget it, man, it's too late. That's all I can tell you.*

According to the 1960 bulletin of the Kansas Ornithological Society, the chuck-will's-widow was known to sometimes migrate up the Arkansas River from the Mississippi as far as Wichita, the farthest west that bird was known to go. Maybe that's how Smith knew it, from growing up on the Arkansas. But he also collected vinyl LPs with recorded insect, animal, and bird sounds, which could explain how he knew it. Or maybe it was because Davis or Hewitt made that call each time they came to the loft and Smith discussed it with them. It's hard to believe that there were numerous visitors to the loft who could whistle that intricate sound, especially loud enough to be heard five floors up through a window.

Later in 2008, I visited Frank Amoss at his home in Santa Ana, California, and I played him this clip of tape. He was

amused and baffled. He had no recollection of hearing the bird-call whistled by anybody during the six months he lived in the building in 1961.

This particular piece of tape says much about the isolation and desolation of this neighborhood in the center of Manhattan. It made the location perfect for a late-night jazz haven—a place easy to stop by on your way to somewhere else, where nobody was around to complain about noise at three in the morning. It also made the place a hole.

Davis and Hewitt disappeared into the New York night and an hour or so later Smith began packing for his first trip to Japan since he was carried off a battlefield on a stretcher in Okinawa during World War II. What unfolded over the next few hours was the most harrowing scene in Smith's entire collection of re-corded sound.

10

SONNY CLARK

Some time after Davis and Hewitt left, while Smith was packing his bags, the pianist Sonny Clark entered the building with his friend the saxophonist Lin Halliday. Smith's tape captured the musicians opening the building's sidewalk door and hiking up the bare wood stairs to the fourth flour along with Halliday's seventeen-year-old girlfriend, Virginia "Gin" McEwan, who was pregnant with their baby at the time. Earlier in the evening, Clark and Halliday had been playing at the White Whale in the East Village with the bassist Butch Warren and the drummer Billy Higgins. Contrary to Davis and Hewitt, somebody in this party had a key.

Clark made it up to the fourth-floor landing and stuck his head in Smith's door. Clark said, *You've got a lot of shit in here.* Smith responded, *I've been shitting for a long time.* They laughed.

Clark and Halliday then sauntered into the hallway bathroom and shot heroin into their veins. Smith's tape captured Clark out in the hallway a while later, moaning to near unconsciousness. Beside him, more coherent, Halliday grew anxious, then flat-out frightened. He sang to Clark to try to keep him awake.

Earlier that summer, McEwan had saved Clark's life with amateur CPR after a similar overdose in the loft (after which—the next day—Smith gave her five dollars to express his gratitude). But now, when Halliday called out for her—*Gin? Gin? Gin?*—she didn't respond; she had already moved somewhere else in the building. The tension mounted as Halliday began to panic. He whistles to get attention. He whistles again. No response.

Sonny, are you awake? Sonny, do you want me to help you? Sonny, don't lie down, sit up. Sit up, Sonny! Don't lie down.

Gin? Gin?

Clark moans deeply and uncontrollably, floating in and out of consciousness. Halliday scat sings improvised lyrics to the Ray Charles tune "Hit the Road, Jack" (which rose to the top of the charts in 1961) to try to distract Clark awake.

> *Sonny Clark's working at the White Whale, pussycaaaat.*
> *He can't get paid, but he get his ass a staaaaash.*
> *He gets his head ripped, and that's all he cares abou-ou-ou-*
> *ou-out.*

Meanwhile, in his room packing for Japan, Smith played vinyl records of Edna St. Vincent Millay reading her poetry and the actress Julie Harris reading Emily Dickinson. He moved back and forth from his loft space to the stairwell, opening and closing the screen door while stacking packed luggage in the hall, the door's stretching spring evoking a fishing cabin or a farmhouse door.

Gene may have photographed and recorded the loft scene but there was a disconnect (between him and the musicians), said Gin, when I visited her in Port Townsend, Washington, in 2006. *Most of the upstairs folk were involved with heroin; Gene, I deeply suspect, was himself a meth freak, a speed freak.*

After an hour or so, Sonny's dose wore off and he regained coherence. He and Lin began muttering about going to the twenty-four-hour automat around the corner for cheeseburgers. They had no money, so Smith gave them a couple dozen glass bottles to redeem for deposits at the grocery store, which opened at 6:00 a.m. You can hear the bottles tinkling on the tape. Lin asked Smith if he wanted anything. Smith asked for a cheeseburger with mustard. Sonny and Lin shuffled down the stairs and out the door onto the sidewalk to run the errand. A half hour later they returned with milk shakes, burgers, and fries.

I remember the last day before Gene left for Japan, said Gin. *Lin, ever the opportunistic and manipulative junkie, but also concerned because I was now pregnant and needed shelter, was trying to convince Gene to sublet his loft to us while he was gone. To sweeten the deal, Lin had gone out of his way to score some sort of speed for Gene. Gene took the drugs but was not dumb enough to capitulate to Lin's wishes. It was the right decision, because in a few weeks I was gone myself.*

It's not clear if Smith ever saw Sonny Clark again. He and Carole Thomas flew to Japan later that day and stayed for a year. On January 13, 1963, Clark died of a heroin overdose in a shooting gallery somewhere in New York City. He was thirty-one.

o

Clark's right fingers on piano keys created some of my favorite sounds in all of recorded jazz. I noticed these sounds for the first time one afternoon in a coffee shop in the Five Points neighborhood in Raleigh, North Carolina, in the winter of 1999. I walked in, a freelance writer seeking refuge from cabin fever. I was working on an article for *DoubleTake* magazine about Smith and the Sixth Avenue loft building, the early days of my research. Over the next hour, I became transfixed by the relaxed, swinging blues floating out of the house stereo system. The multipierced barista

with multicolored hair showed me the two-CD case, *Grant Green: The Complete Quartets with Sonny Clark*. Green was a guitarist from St. Louis with a singing single-note style that blended beautifully with Clark's effortless, hypnotic right-hand piano runs. She said, *This is the epitome of cool.* True. It was also smokin' hot. And I heard a country blues twang in it. The nineteen tracks were recorded in December 1961 and January 1962 by the Blue Note label, but they weren't released until many years later, after both Green and Clark were long dead.

I began devouring all of Clark's recordings, some of which were available only in Japan. From 1957 to 1962, he was documented on thirty-one studio recordings, twenty-one as a sideman and ten as a leader. Most of Clark's recorded work is as singular as the sessions with Green; his presence on piano creates not only the sound of one instrument but also an atmosphere simultaneously light and melancholy.

"Bewitching" is the word the *New York Times* jazz critic Ben Ratliff used to describe Clark's performance of "Nica" on a 1960 trio recording with Max Roach on drums and George Duvivier on bass. "It's funky and clean and has the tension of changing tonality, so that within four bars it keeps changing from easy and secure to full of dread."

I wanted to figure out what had happened to Clark, and to learn how it came to be that his life intersected with Smith's in such a powerful and horrifying and yet somewhat random and ordinary manner.

In my conversations with Clark's two surviving sisters, a number of his childhood friends, and many musicians, as well as in my research in libraries, I came across more than one indication that his recording sessions exacerbated his drug addictions.

Sonny made mistakes, said the trombonist Curtis Fuller, who played with Clark on a number of recordings. *He could have had a*

brilliant career. I don't want to know about what happened to him. We all have troubles. It's a wild and crazy life, especially for black people at that time, trying to make it. There was a lot to deal with that white people can't know no matter how hard they try. That part of history was unkind for a lot of us. I don't want to go there. I don't care to talk about it.

o

Conrad Yeatis "Sonny" Clark was born in 1931 in Herminie No. 2, Pennsylvania. ("No. 2" refers to the second shaft of the Ocean Coal Company; the nearby larger town around the first shaft was just plain Herminie.) He was the youngest of eight children born to Ruth Shepherd Clark and Emory Clark. Sonny's parents came from rural, Jim Crow Georgia and moved to Pennsylvania so Sonny's father could work in the coke yards of Jones & Laughlin Steel. They ended up in the coal-mining village after being chased by the KKK, and Emory died of black lung disease two weeks after Sonny was born.

After his father's death, the family moved into the black-owned Redwood Inn a few hundred yards down the road. Named for its owner, John Redwood, the inn hosted a thriving social scene for African Americans. Redwood's daughter, Jean Redwood Douglass, remembers, *The inn had twenty-two rooms, a dance hall with a jukebox and a pinball machine, and a little store. On weekends, black folks from all over the region came for dances, and black musicians from Pittsburgh came out to play. Sonny began playing piano at age four, and he was still very young when he began playing the weekend dances. He could play any instrument besides piano, too. I remember him playing xylophone, guitar, and bass. Everybody marveled at him.*

Clark was the pride of the family. By age fourteen, he was getting notices in the *Pittsburgh Courier*, the famous black paper, and he became a fixture in the city's rich jazz scene. One *Courier* article indicated Clark was twelve years old when he was actually

fifteen, and no doubt he looked younger (he was five foot four and 130 pounds, full grown). A bout with Bell's palsy as a child had left one side of his lower face slightly stiff and affectless, like a shy kid dribbling words out of one side of his mouth.

Ruth Clark died of breast cancer in 1953, and the Redwood Inn burned to the ground around the same time. The family dispersed. By the time Gene Smith went to Pittsburgh in 1955, most of the Clark family was gone.

Sonny Clark followed an aunt and brother to California, where he rose to the top of the jazz scene, becoming a regular at the Lighthouse jazz club in Hermosa Beach, near Los Angeles. The scene was inundated with alcohol and narcotics, and Clark was soon hooked. He moved to New York in late 1956 or early '57, at age twenty-five. He would kick the habit for brief periods, often by checking himself into Bellevue, or by visiting the controversial psychiatrist Robert Freymann (whom the Beatles reportedly referenced in their tune "Dr. Robert"), but he couldn't stay clean.

The first time I remember meeting Sonny Clark, I was working as a waiter at the Five Spot Cafe in Cooper Square in Manhattan in 1957, said the jazz bass player Bob Whiteside. *At the time, Sonny was working as the chauffeur for Nica {Baroness Pannonica de Koenigswarter, a wealthy patron of jazz musicians}, and he came in with her and Thelonious Monk. Monk was playing with his quartet, which included Johnny Griffin, Roy Haynes, and Ahmed Abdul-Malik. I knew Sonny had played piano on some wonderful records, but that's about all I knew. His appearance was not that of a dope addict. He just seemed like a nice dude.*

De Koenigswarter had hired Clark to be her driver and put him up in her New Jersey home in order to help him kick his drug habit. His addictions were a topsy-turvy struggle, but people liked him personally and wanted to help him, including

Gene Smith, who was known to let Clark "borrow" some of his equipment so Clark could pawn it.

Sonny was my man, said Fuller. *We were instant friends, about the same age. He was a young scholar of music. He had the same personality as Coltrane, dead serious about his music. He was also a great writer. He was hip. He had a different type of creativity, a unique and special touch, and an old-fashioned quality that was also very modern.*

But the barrage of early success in New York had an underbelly: Clark's drug addictions worsened. His increasing reliance on narcotics periodically reached a head and would culminate in disappearances. From 1958 to 1961, he had six-, seven-, and thirteen-month absences from an otherwise prolific recording career. Each time, he'd resurface and record some beautiful music; then he'd disappear again. In 1961, he was a regular at 821 Sixth Avenue, squatting in the loft hallways.

In my quest to learn more about Clark's life and times, especially the part of his life documented on Smith's tapes—the rarely documented part—I picked through every jazz magazine published from 1957 to 1962, looking for any clues. In the August 1962 issue of the indispensable Canadian magazine *CODA*, I found this report by Fred Norsworthy on an unnamed musician who is probably Clark: *One of the saddest sights these days is the terrible condition of one of the nation's foremost, and certainly original, pianists . . . I saw him several times in the past three months and was shocked to see one of our jazz greats in such pitiful shape. Unfortunately, the album dates that he keeps getting only help his addiction get worse instead of better.*

The ambiguous relationship between black musicians and white-owned record labels is demonstrated poignantly in August Wilson's play *Ma Rainey's Black Bottom*: it was bittersweet, lopsided but mutually dependent, and not that much different from the company-owned coal "patch" environment in which Clark

was born and raised, with money holding inextricable power. Wilson's play is fiction; not many voices have been willing to describe the relationship in nonfiction terms. In his seminal 1966 book, *Four Lives in the Bebop Business* (republished in 2004 as *Four Jazz Lives*), the African American poet and historian A. B. Spellman quotes the saxophonist Jackie McLean, concerning an unfair record deal McLean agreed to while addicted to heroin: *I was starving when I signed that contract . . . And my condition didn't help, either; any money was money then . . . The record companies today are aware of what the cat's problems are. If they weren't aware that there aren't many jazz clubs going and that record dates are a necessity to many musicians and that some musicians use drugs, there would be more jazz musicians around with money.*

When I asked Spellman to elaborate on the relationship between labels and addicted musicians, he said, *Record labels kept stables of drug addicts. Addicts were always borrowing against royalties, and they were always behind on paying back the money. So one way they'd pay back their debts to the labels was by playing a new recording session, because the addicts never had money to pay them back. The record label's side of the story is hard to contradict: the musicians owed them money, and the label executives could show that they lost money on the deal. The appearances of this situation looked unhealthy to many of us. The musicians were owned, almost. But it's hard to stand up for junkies, because it's hard to justify their behavior and, it's true, the labels did loan them a lot of money in advance. You have to see both sides.*

o

Today, Clark's recordings are more popular in Japan than in the United States, even though he never visited that country. According to SoundScan, which began tracking CD sales in 1991, Clark's 1958 album on the Blue Note label, *Cool Struttin'*, has, in Japan, outsold several Blue Note albums with similar instrumen-

tation from the same period that dwarf *Cool Struttin'* in terms of iconography and sales in the States. For example, from 1991 to 2009, *Cool Struttin'* sold 38,000 copies in the States and 179,000 in Japan, while over the same period, Coltrane's classic 1957 release, *Blue Train*, sold 545,000 copies in the States and 147,000 in Japan.

The producer Michael Cuscuna organized a tribute to Clark at the Mount Fuji Jazz Festival in 1986, and the band opened with the title track of *Cool Struttin'*. *Within the first five notes*, said Cuscuna, *the crowd of fifteen thousand people roared with recognition.* At the most sophisticated festivals in the States—say, San Francisco, New York, Monterey, or Newport—such recognition of Clark's music is unthinkable.

I asked the novelist Haruki Murakami, who once owned a jazz club, why *Cool Struttin'* is so popular in Japan. He attributed it to the rise of the "jazz kissa" (jazz coffeehouses) in the 1960s. "The popularity of *Cool Struttin'* was not driven by professional critics or by sales," wrote Murakami by e-mail, "but instead by youths who didn't have enough money to buy vinyl records, so they went to coffee shops to hear jazz on the house record player. This was a phenomenon particular to Japan, or at least very different from America." Clark's buoyant blues fit the underground mood of Japan's postwar youth. It didn't hurt that his tragic life made him an unconventional, forlorn icon, too.

The symbols that frequently come up in Japanese writing to describe Clark's music are 哀愁, pronounced "aishuu." As often is the case with Japanese aesthetic terms, there isn't a direct English translation of the phrase. The first symbol can be read as *ka-na-shi-i* (哀しい) or *a-wa-re* (哀れ). The former means moving, sad, and melancholy. The latter can mean compassion, compassion-inducing, sympathetic, and touching. The symbol is made up of 衣, which means clothing or an outside covering, and 口, which

means mouth. These symbols together mean covering, suppressing, or muffling an expression of feelings.

The second symbol is usually read as *ure-eru* (愁える), which means to feel lonely, to lament, to grieve, be fearful. It's made up of the symbols 秋, which means autumn, and 心, which means heart. In the fall, everything contracts, or tightens, such as trees and plants. Therefore, the symbol 愁 means the contracting or tightening of the heart and expresses a mysterious atmosphere of pathos and sorrow.

o

On May 8, 1960, inside the loft, Gene Smith made an audio recording of Edward R. Murrow's CBS program *Small World*, from Channel 2 in New York City. During the program the writers Yukio Mishima and Tennessee Williams compared Japanese aesthetics with those of the American South.

Mishima: I think a characteristic of Japanese character is just this mixture of very brutal things and elegance. It's a very strange mixture.

Williams: I think that you in Japan are close to us in the Southern states of the United States.

Mishima: I think so.

Williams: A kind of beauty and grace. So that although it is horror, it is not just sheer horror, it has also the mystery of life, which is an elegant thing.

This "very strange mixture" of the brutal and the elegant may describe what Japanese jazz fans hear coming out of Clark's piano, a ventilated swing drenched with minor blues. Gene Smith's trademark printing technique contained a similar aesthetic mixture.

o

On the two nights before Sonny Clark died—January 11 and 12, 1963—he had played piano at Junior's Bar on the ground floor of

the Alvin Hotel on the northwest corner of Fifty-second and Broadway. The next thing we know with certainty is that Nica de Koenigswarter called Clark's older sister in Pittsburgh to inform her of her brother's death. Nica said she would pay to have the body transported to his hometown and that she'd pay for a proper funeral. We don't know, however, if the body in the New York City morgue with Clark's name on it was his.

Witnesses in both New York and Pittsburgh, after the body arrived there, believed it wasn't Sonny. Some suspected a conspiracy with the drug underworld with which Clark was entangled, but, as African Americans in a white system, they were reticent. It was probably a simple case of carelessness at the morgue, something not uncommon with "street" deaths at the time, particularly when the corpses were African American.

Today, there's a gravestone with Clark's name on it in the rural hills outside Pittsburgh, where a body shipped from New York was buried in mid-January of that year. But even while the funeral proceeded, no one was sure where Sonny's body was. His may be one of the thousands of unidentified bodies buried in potter's field on New York's Hart Island, where Sonny himself dug graves years earlier, when, on drug charges, he was incarcerated at Rikers Island.

WHAT HAPPENED TO RONNIE FREE?

On that morning of September 25, 1961, when Clark, Halliday, and McEwan entered the building, before Clark overdosed, Smith recorded this exchange:

Halliday, to Smith: *Hey, when you get over there {Japan}, look for some methedrine because, you know, that's where they invented it. When you come back, I'll be working. Boy, I wish you all the best. I know I'm corny, but you sure been good to me.*

(Pause.)

Halliday: *You don't have Ronnie Free's number, do you?*

Smith: *I don't have the slightest idea where Ronnie is.*

o

Free left New York abruptly in 1960 or 1961 and never went back. He didn't show for a gig with Marian McPartland and nobody saw him again. In 2001, McPartland told me, *I was thrilled to have Ronnie working with me in my trio at the Hickory House. He was considered the great young hope among drummers on the scene, a really wonderful player. He had a different style, more swinging, very subtle. Free is a good name for him. He didn't play bombastic solos like*

many drummers did. Ronnie was one of the best I ever saw. Then one night he just disappeared. We had a gig and he didn't show up. Nobody saw him after that. Thirty or thirty-five years later, in the early 1990s, I was walking down the street in Columbia, South Carolina, and I couldn't believe my eyes, but Ronnie Free was walking right toward me, looking exactly the same. My first words to him were, What happened to you?

o

Ronnie Free is the most ubiquitous presence on Smith's recorded tapes other than Smith himself. He is documented playing drums on more than a hundred reels, roughly 250 hours.

One night in 1960, Free shared his drum kit with Roy Haynes. *These your drums, Ronnie?* Haynes asked. *Yeah, man. Here are some sticks.* This is one of the few times Free's voice can be heard on the tapes. Usually it's just his drumsticks tapping the surfaces of his instruments, sometimes wood-shedding by himself, or in tandem with the saxophonist Freddy Greenwell, or with the pianist Hall Overton, or the three men forming an ad hoc trio. Other times, he can be heard in explosive jam sessions with dozens of musicians. No words from Free, just percussion.

In a 1965 lecture at the Rochester Institute of Technology, Smith, traveling with a portable tape machine, recorded himself making the following comment: *They {the musicians in the Sixth Avenue loft} were searching for something they can't find in their club dates. One night, a saxophonist named Freddy Greenwell came in after midnight on a Sunday night. A drummer named Ronnie Free was there. They started jamming together, and they continued to play until Friday, almost without stopping. Ronnie was a brilliant young drummer, and he drove the session along with tremendous fury and grace. He was working on something, searching for something, and he kept playing until he found it. Many different musicians dropped in throughout that week and played.*

They'd leave, and Ronnie and Freddy kept right on playing. It was an amazing show of determination. I was inspired by it. I try to put that level of determination in my own work.

○

March 24–25, 1960. Smith is talking with the saxophonist Zoot Sims, the pianist Bill Potts, and Free, who has lived in the loft for roughly two years by this time. Potts is noodling around with notes on the piano keyboard.

Sims: *Do you dig these fucking wires and mics, man?*

Potts: *I like this. I like this pad, man. I want to get a pad like this.*

Sims: *Yeah, well, let's move in . . .*

Smith screams in protest: *ARRRRRRGGHHHHHH!*

Free: *I'll probably be moving out before long.*

Sims: *You gonna be moving out?* Then, to Smith: *He's been with you all the time, man?*

Smith: *Ever since I made the mistake of inviting him in for a couple of hours.*

Potts: *Then he stayed for a few years, huh?*

Free: *Shit, I ain't got no watch.*

[*Laughter.*]

○

When I discovered Smith's tapes in 1998 and began researching the Sixth Avenue loft, Free's name often came up in interviews with musicians, but nobody seemed to know where he was or if he was still alive.

Free was indeed still alive. Earlier in 1998, he had written a brief memoir in "The Note," a xeroxed, stamped newsletter mailed out by the jazz archive at East Stroudsburg University of Pennsylvania. In the piece, he mentioned sessions at Smith's Sixth Avenue loft. By word of mouth, I was alerted to that piece

and I eventually found my way to Free, who was living in Hot Springs, Virginia, playing drums in obscurity at the Homestead Resort.

If Smith's career were measured by the amount of time and resources he spent on his subjects, Free would be up there in significance with Maude Callen or Albert Schweitzer, the subjects of two of his most iconic photo-essays. But Free wasn't the subject of a journalistic assignment, which made Smith's documentation of him more revealing. We see what Smith was drawn to document when there was no expectation or deadline.

○

Ronald Guy Free was born on January 15, 1936, in Charleston, South Carolina. His mother, Daisy, was a bartender, and his father, Herbie, was a card dealer, taxi driver, and garbage collector for the city. His sister, Joan, was born two years earlier. The family lived at 38 Spring Street in one of Charleston's poorer neighborhoods on the border between the black and white sections of town. Herbie Free was by all accounts a violent alcoholic. Daisy was a sweet, earnest woman, but no match for her husband's drunken tirades. Herbie never became the musician he wanted to be, so when Ronnie expressed an interest in drums at age six, Herbie pressured him to pursue it.

Ronnie's father was cruel, awful to him, said the late Ms. Dale Coleman, a former writer, schoolteacher, and a close friend of Free's since their shared childhoods. *He forced Ron to practice until his fingers bled. He was proud of Ron's ability, but he always told Ron he was no good. The only expressions he ever made were violent ones. You name it, he did it to Ron—screamed at him, kicked him, beat him, slapped him.*

Ironically, I owe much of my practice skills to my old man, says Free. *I developed my ability as a result of my father forcing me to practice as a*

kid. Somewhere along the way he decided that I had to become the best fucking drummer there ever was. He would come home drunk in the middle of the night, wake me up, and make me show him what I'd learned that day practicing on the drums, the rudiments. If he didn't think I was playing well enough he'd slap me upside the head, kick me, pinch me, beat me. Then, the next night he'd come home and be the opposite, hugging me, telling me how much he loved me, telling me I was going to be the greatest drummer that ever lived. Smelling like liquor the whole time, whether he was beating me or hugging me, it was one extreme or the other. All of it was inappropriate, to say the least.

I realized if I became good enough, the drums were my ticket out of town. I enjoyed playing, though. The sound of drums always has seemed to fill me with courage, inspiration, and the feeling that anything was possible. Drums have a history of use in warfare as a means of providing troops with courage. It works that way for me, too.

By age eight Ronnie was taking drum lessons from a local teacher, Patrick Leonard. *He practiced religiously,* said the late Leonard. *I recall passing his house on Spring Street when he was a little boy and seeing him out there on the front steps practicing with his drumsticks.*

Coleman and other childhood friends said that Free would turn a chair or milk crate bottom-up and knock his sticks on them for hours. At twelve, Free began sneaking into bars and clubs and playing with jazz and blues bands on the white and black sides of town.

With the blessing of his parents, Free quit school at age sixteen in 1952 to go on the road with Tommy Weeks and His Merry Madcaps, a music and comedy trio. *I waved goodbye to my parents at the bus station in Charleston, off to seek my fame and fortune,* says Free. *The Madcaps were a terrible trio with funny hats and bad jokes and all that, but it allowed me to see much of the country. When we got to Minneapolis, I left for a better-paying job playing the girlie*

show with Royal American Shows, a touring carnival out of Tampa, Florida. It was an amazing experience, traveling on the road as a teenager with all the freaks and carnies.

By 1955, Free was being influenced by Max Roach's drum work on records with the trumpeter Clifford Brown and the saxophonist Sonny Rollins. He realized he had to move to New York City to play with musicians of that caliber. He moved in with a family friend on Staten Island—a man named Dick Tarrance who had been a boarder in Free's childhood home in Charleston. Free found jobs playing for lounge singers and comedians on Staten Island until he obtained his Local 802 musicians' union card, which would allow him to play in Manhattan. The city made a deep impact on the young artist.

Dick Tarrance had this house on top of this, like, a series of hills on Staten Island, with a beautiful picture window. I'll never forget, the first day I was there, I think was around Christmas of 1955—and it snowed the first morning. We got up and we opened those curtains. I'm from Charleston, South Carolina, where it never snows and there are no hills. Everything's flat and straight. I'll never forget that morning looking out over those layers of hills down below me, and those snow-covered rooftops. That was one of the most breathtaking sights I've ever seen.

A few months later Free received his union card and began working in Manhattan.

There's no place quite like New York, particularly in my mind, because I'd been hearing about New York all my life, the milieu. All the musicians that came through Charleston when I was a kid, any of them you talked to, they'd say, Well, you've got to go to New York.

So I had these ideas of the Great White Way, you know, instant stardom and fame and fortune, and all these ridiculous ideas. Then to suddenly be there, it was like I was in a storybook or something. It was a surreal experience for the longest kind of time. I remember I stayed overnight in a hotel one time in Manhattan, when I was still living

on Staten Island. I'd had a gig and it was too late to take the ferry back to Staten Island. My room was on the second floor of a funky little hotel. It was just a couple of doors off Broadway. It was somewhere in the Forties, I think. It didn't even have any screens or anything in the windows, but I could open my window and I could look out that window onto Forty-sixth Street or whatever street it was, and a little farther down I could see Broadway there. It was like a child looking through a magic mirror or something. That went on probably for the first couple of years in New York, of just feeling like I was Alice in Wonderland, that kind of thing. {Sighs.}

It was scary, because Charleston is a little sleepy Southern town. New York makes you feel really, really, really, really small and unimportant. I already felt that way before I left Charleston, so it's just like {sighs} the loneliest I've ever been was in New York City surrounded by all those people. Even when I was with friends or whatever, I still felt lonely because they all seemed to feel at home there, you know, and comfortable there and seemed perfectly normal, whereas I'm still in this surreal otherworld kind of thing.

So, it was a major culture shock. There's a lot to fear. I was very fearful anyhow, because I had no self-confidence. I was confident that I wouldn't amount to much {laughs}, so I kept getting these shocks because I kept getting these gigs, man, with all these guys I'd read about in Downbeat *magazine and* Metronome *and blah-blah-blah. Some of them I'd had pictures of on my bedroom wall, and things like that, man, and here I am gigging with these people.*

I just tensed up, man. I was just—fear is a form of faith. And belief is very powerful, regardless of what you believe. If you believe positively about something, it's very powerful. But if you believe negatively, as I did, because I was damaged goods when I arrived on the scene because of my—I have a very abusive childhood thing that I'd never really learned how to cope with. {Clears throat.}

Free's first official gig in New York was in the pit band for an

off-Broadway show called the *Shoestring Revue*. The eminent bassist Oscar Pettiford attended one of the shows and was taken by Free's solos. *Oscar—O.P.—called me a few nights later and had me play with him on a few record dates*, says Free. *I started getting these incredible gigs overnight. But it all was happening too fast.*

After I got to New York, yeah, everybody was pretty much smoking pot, and Shadow Wilson introduced me to heroin. He was definitely a childhood hero of mine. I first caught him at Birdland when I was about twelve years old when my parents had taken me to New York. Shadow was playing with Erroll Garner and playing mostly brushes, and he just knocked me out. It was so tasty and swinging so hard, and everything was just perfect. After I moved to New York—this was six years later, you know—I met him at Café Bohemia one night. He was working with Roy Eldridge. Somebody introduced us and told him I was a new drummer. The first words out of his mouth were "Ronnie, you want to get high?"

So, I thought he was talking about grass. I said, "Sure, man." So he says, "Come on downstairs." He whipped out this little packet of white powder and took a matchbook cover and scooped some up off the corner of the matchbook. He tore off a piece of it, scooped it up, and offered it to me. I didn't even know what I was supposed to do with it. So, I said, "No, you go ahead." {Laughs.} So he goes {sniffs}, "Ugh." So, I go {sniffs}, "Ugh." I think we did it at least once or twice in each nostril.

Then he said, "Come on, let's go across the street. There's a little bar over there. We'll get a beer." So I made it as far as the alley and puked my guts out, man, got sick as a dog. After that, though, it felt pretty good. That was the beginning of something pretty awful.

At age twenty, Free's career and lifestyle took off: *One night, I met O.P. at Junior's Bar, and Woody Herman was there. O.P. kept telling Woody how good I was. The three of us left the bar and went to O.P.'s apartment, where he and I jammed while Woody listened. A few days later Woody's manager called me and offered me the drum chair in*

his band, a band I'd been listening to with my parents as a kid. Some of my heroes were in that band. It was unbelievable! But I wasn't ready emotionally. I was scared, I lost all my confidence. I had a recurring nightmare where I was playing drums with sticks the size of baseball bats. I couldn't keep up with the band's tempo—the sticks were so heavy— and Woody would be standing in front yelling at me to play louder. It was awful. I'd break out in puddles of sweat, man. I was so paralyzed by fear, I couldn't hear the music at the rehearsals or gigs. I couldn't get it together. If you are scared, you can't hear the music.

Free lasted only a few weeks with Woody Herman's band in 1956. Herman fired him after a disastrous gig in Cleveland. Herbie and Daisy Free had driven to Cleveland to see Ronnie play that night. Free was devastated.

I was in tears backstage. The vibraphonist Vic Feldman, a real gentle soul, tried to console me, says Free. *He told me it wasn't the end of the world. But all I could think of was that it was over. My parents had driven all the way from Charleston to see me get fired.*

Free returned to New York and continued to land good jobs, but his drug use mushroomed. He kicked his heroin habit by taking cough syrup with codeine to take the edge off. But he began consuming larger quantities of alcohol, marijuana, and especially amphetamines. *I was a neurotic, screwed-up mess,* says Free. *If I found a pill on the street, I'd pop it in my mouth not even knowing what it was. At one point, I was taking about a hundred amphetamines a day.*

Free found homes in several different lofts around New York, ultimately setting up his drums at 821 Sixth Avenue in 1959. He was at home in the casual atmosphere, without public pressures, and there he did his greatest work.

○

I asked Free to describe his relationship with Smith inside the loft: *Well, Smith was—he was a case. I never got to know him real*

well. He was always working and always had all kind of projects going. He'd have tables and countertops all just covered with pictures and negatives and charts and graphs and God knows what all—tapes, because he taped all the sessions and everything. But I don't remember ever really having a conversation with the man, to tell you the truth. He was very much into his work, and I was into the music. It was kind of a mutual coexistence, more than anything. He was always busy doing his thing, and I was busy doing mine, and that's about it. We had, you know, a level of friendship because I know if he was broke, he had no qualms about asking me if I had any money, and vice versa, you know. We would swap goodies—he would give me some of what he called "psychic energizers," and I would give him Desoxyns or whatever I had. I think he had a prescription for them, whatever they were. It just sounded like something you'd want to try. "Oh, yeah, I'd like to energize my psyche," you know. We were both desperate, when you get down to it.

One thing that's not talked about often is that you kind of almost have to hide out in order to develop your craft. You have to be isolated in order to practice enough to be any good. That's what Smith's loft provided, a place to isolate and practice. It was almost like an underground thing that was built up around a whole music culture—art in general, you know. They've always been relegated to attics and lofts and cellars and smoky nightclubs and so forth. So, that's a stressful situation, and you're in environments where people are drinking and carrying on and so forth.

But I don't see it as that different. I guess musicians got a little more—I can't even say that! I started to say that musicians maybe carried it to an extreme that most people don't, but there are a lot of people in so-called straight society, man, that are fucking alcoholics and drug addicts, lunatics dressed as conventional folks. And who even knows to what extent all that is going on? So I'd just like to get away from that stigma about it, because, you know, it's not that different.

I asked Free how it came to be that he left New York City abruptly and never went back. His ensuing story took five and a

half hours to tell, with several breaks, including one break over-
night. Gene Smith plays a central, if subtle, role in the story.

Things started changing for me when I was working at the Village
Gate with Mose {Allison}. I forget who was playing bass. We were play-
ing opposite Horace Silver. This was his band with {the trumpeter} Blue
Mitchell, and was it {the saxophonist} George Coleman? Roy Brooks
was playing drums. I forget the bass player's name. But I had hit kind
of a low. I had been all through the roller coasters of being on top one
minute and skid row the next, and all points in between. I had serious
drug problems.

No matter what I did to myself—I thought I'd be instantly healed
if I got to play with {certain musicians}, you know, this band or that
band, or if I played in this venue. I would get the recognition and all that
would make me feel good about myself, make me confident, and make me
feel healthy, you know, give me some self-esteem. But I was still the same
screwed-up neurotic mess, no matter what. Things were getting worse by
the day. Of course, the longer you're in it, the harder it is to get out, and
I was just really depressed. I just bottomed out.

So, I'm working at the Village Gate with Mose Allison, who was
kind of—you know, he was pretty popular at the time. I loved the gig
and so forth, but again, I had this inner turmoil, this conflict, this para-
noia or whatever it was, this psychosis. I can't emphasize how bad off I
was at the time. I'd reached a point where I could take a hundred pills
and not feel anything.

One night before the gig, I had some kind of a little skirmish with
Mose. He had always done me nothing but good, man. He'd get me gigs,
he'd put me on records, and so forth, when nobody else would hire me. He
was kind of like a loyal friend and mentor. On this night, though, we
had some words over something silly, something that's unimportant, because
it was all in my head, basically, or at least ninety-eight percent of it. So,
that really bummed me out, because we'd always gotten along so well
and enjoyed playing together so much, and I was always so thankful and
grateful to him for liking me and my music.

We went on the bandstand after this little skirmish and something clicked. I played the best I've ever played in my life, with the greatest of ease. There was a total sense of ambidexterity. Anything I could think of I could execute it precisely where it should be at the right exact moment every step of the way.

We played, and we swung our asses off. We really connected. It was like a whole new level for me, as far as any experience that I had playing music up to that point. This was just like otherworldly, man, like a level of perfection that I had never even thought possible.

We got off the bandstand—and, I should say, our argument had a racial aspect to it, where I perceived Mose had made a racial remark of some kind in reference to Horace Silver. In retrospect, I could see it was just Mose's little dry humor thing. I don't remember exactly what he said, but I know I had interpreted it totally through my fucked-up psychotic lens. But the conflict had fueled the music somehow. Anyhow, we get off the bandstand, and there's a table of black people sitting off to the side, and one of them calls me, "Hey, drummer!" I looked over, and he said, "You're all right."

I walked back to the bar, and the bartender told me that some guy had been sitting there asking questions about me, had been saying things about me. I walked out to the hallway, and {the pianist} Carla Bley was the hatcheck girl at the time. She said, "Oh, I've got a message for you." I said, "Yeah, what's that?" She said, "I was told to tell you that some strange man said that you are really great."

These seem like little things, but they added up quickly. I'd never had messages like this. I went into the men's room, went into the booth and locked the door, and fell down on my knees and was crying like a baby, man, because of the power of this whole experience. It was like I had been saved from the fucking jaws of—from the abyss.

I walked home from the gig that night, living in the loft with Gene, and I opened the door, and there Gene had a folksinger sitting on the stool {probably Nechama Hendel, an Israeli folksinger that frequented the loft at the time}, strumming a guitar and singing religious, spiritual songs

that really resonated with me on the heels of this profound experience I just had at the Village Gate.

I went to the back room of the loft and sat down in this recliner that Gene had there. I asked God to show me his face. Looking at the wall, suddenly I see this sheep's head dipping down into a pool, drinking water. His head would come back up, and you could see the water dripping from his lips, and you could recognize it as a lamb. In the background, I could see these wings flapping, and I recognized it as a dove.

Now, this must be some kind of subconscious imagery that was buried down in there that I got from Sunday school. My mother used to make us go to Sunday school as a child. So I don't know where it came from, but I recognized the symbol of the lamb and the dove being the face of God. I felt like my prayer had been directly and immediately answered, man!

Later I learned the technology behind it. Over my shoulder, back behind me on one of Smith's bookcases, there was a lamp, there was a glass of water—oh, there was a vase with a flower in it, a long-stemmed flower. There was a glass beside the vase, and Smith had a fan in there, one of those oscillating fans. The wind from the fan would blow the flower into the glass, and it would come up dripping water. It cast a shadow on the wall, and it looked exactly like a lamb's head. The wings were an open book lying there on the shelf with the pages flapping from the fan.

But the reality of what I was seeing didn't make the experience any less valid for me. I went through about a week of that, of just one thing right after another, and one confirmation after another.

Gene had shelves and shelves of all kinds of books imaginable. I'd pick up a book, and I'd open it randomly, and words would just jump out at me. So I was just plugged into a whole different level of experience there. I'd had this profound awakening.

Gene had books on Buddhism, Hinduism, Christianity, Judaism. He had the Torah and the Bible and the Bhagavad Gita and the Koran. It was like a library in the loft. I had everything imaginable right there at my fingertips. I was reading these Eastern guys, and these guys actu-

ally made sense. It was a whole different approach from anything I'd seen. I'd hole up in there for days, never even leaving the damn loft. Between playing drums and reading and catching a little snooze every now and then, I was just content to stay in there and just saturate myself.

You have to remember, I dropped out of school at age sixteen, and I was only in my early twenties at this time, so when I read these words— "When the student is ready, the master will appear," or "the teacher appears," or something like that—I almost could hear like a gong in the background going, "Duhhggg!" I thought to myself, "I'm ready! Sitting on ready!"

I went forth in search of the master. So, I went out late one night and I started walking the streets. I wound up . . . it must have been down in the Twenties somewhere. I think I was walking eastward. Maybe it was down toward the Village a little farther, possibly even the East Village.

I passed a bunch of what looked like winos sitting on a stoop passing around a bottle of wine from person to person. There was a scrawny little black guy—maybe five foot six or seven—there with a really big mouth and an obnoxious-sounding voice that was kind of dominating the scene. I walked on by. And the next thing I know, this guy had left his group and was walking right by me. He said, "Excuse me, sir, would you mind if I walk along with you?"

I said, "I'm not really going anywhere in particular," or something like that.

He said, "Well, if it's all the same with you, sir, I'd rather walk with you. My name is Little Jimmy John Junior."

The master had appeared, Free said, laughing.

<p style="text-align:center">o</p>

The story that unfolded from this point took Free more than three hours to tell. We took several bathroom breaks and so Free

could walk his dog, a yellow Labrador named Nugget, in the crisp and clean Appalachian mountain air.

When we sat back down inside and Free resumed telling his story about Little Jimmy John Junior, he annotated his story with periodic comments like, "I know this makes no sense" and "I know my sequences are going to be out of order."

The basic story went like this: the two men spent three days wandering around town, getting thrown out of bars for being rambunctious and obnoxious, dashing across intersections in the middle of traffic, making cars slam on brakes, not worrying or caring about the consequences of anything they did. At some point along the way, Free and his master separated and Free kept performing the uninhibited movements and behaviors on his own. He ended up being picked up by police and committed to the mental ward at Bellevue.

Word of what happened to Free made it back to the Sixth Avenue loft. The story he told me resonated with the faint memories of just a few surviving musicians from the loft. For example, in an interview at his home in Bellingham, Washington, in June 2005, the pianist Joey Massters remembered that Free had been picked up by police for "wild jaywalking through the streets" and committed to Bellevue. The bass player Sonny Dallas had a similar memory. Both musicians visited Free during his confinement.

A couple of weeks later, Herbie and Daisy Free drove up to New York and released their twenty-four-year-old son from Bellevue. They took him back to Charleston. After a period of recovery and sobriety, Free returned to New York and reengaged the scene, settling back into Gene Smith's loft.

It was a fresh start. Free pursued gigs anew. He landed the prime opportunity with Marian McPartland. Things were looking up. Then, on one random evening, walking up Sixth Avenue to the Hickory House for work, Little Jimmy John Junior came

busting out of a random doorway and into Free's path. The wild spree started all over again. He didn't show up for his gig with McPartland. He ended up in a fetal position on the floor of an unknown bathroom.

Something came over me. I don't remember what led up to it, but I remember lying on the floor in this bathroom, literally crying like a little baby, uncontrollable crying. It seemed like I was even kicking my hands and my legs and arms like a little baby does, you know, "Wah! Wah!" I was thinking about my mother. It was like a whole wave of memories and things came washing over me, taking me way back to babyhood, much less childhood. There was all kinds of really tender feelings and love and just adoration for my mother, and it was like I really reverted back to babyhood there just for that period, however long it took. I'm not sure if it was minutes or hours or days.

Whenever it was over, I felt completely cleansed. I felt like I'd washed away years of trauma and inhibition and uptightness that I didn't even know I had. I felt free, man. I just really felt like I had just dropped all my hang-ups. It was an incredible experience. I thought, "Well, okay, my work here is done."

I quit playing altogether. I went back to Charleston and never came back. I called Smith's loft and had somebody ship my drums back down to Charleston. I burned them in the yard.

PART V

TAMAS JANDA

In the fall of 1958, things weren't going well for eighteen-year-old Tommy Johns. He had graduated from Croton-Harmon High School that year and was working as a janitor, while living with his mother and stepfather and four younger siblings in an unheated, drafty wood house about two hundred yards from the railroad tracks and the Hudson River. His parents had money for beer, cheap liquor, and little else. One morning, Tommy got up, put on his oversized, secondhand Swedish army coat, told his family he was going to the corner store for cigarettes, and hitchhiked fifty miles to Manhattan.

Let out of the car in Greenwich Village, he wandered up Sixth Avenue, choosing that route for no particular reason. When he crossed the intersection at Twenty-eighth Street, he suddenly recognized the familiar figure of Gene Smith standing on the curb next to a tractor-trailer.

Tommy had gone to school with Smith's son, Pat, and daughter Marissa, in Croton. He visited the Smiths' spacious stone home in a quiet leafy neighborhood on the other side of town. Tommy knew that Mr. Smith had been a famous photographer for *Life*,

covering World War II and other important subjects, and here
he was, standing on the sidewalk smoking a cigarette and look-
ing forlorn.

Smith saw the kid approaching:

Tommy, what the hell are you doing here?

I left home this morning. I just ran away.

*Well, we have something in common. I just left my wife and family.
I got this truck with all my stuff. I need somebody to help me move it into
my loft here. I need somebody to build shelves and cabinets and organize
everything. You need a job?*

Johns stayed in Smith's loft for two years.

o

Tommy Johns joined a roster of outcasts that found their way up
the stairwell at 821 Sixth Avenue and into Smith's isolated and
obsessive world. Smith scratched "Tommy Johns" or "T. Johns"
in pencil or pen on more than twenty labels of his reel-to-reel tapes,
but Johns's identity remained one of the lasting mysteries of my
research for a dozen years or more, as I was searching for the people
Smith documented.

I learned to recognize Johns's occasional voice on the tapes.
He didn't seem to be a musician, more a phantom. I imagined
him relaxing ten feet from the recorder, smoking a joint and
drinking a Rheingold—barely audible, just taking in the scene.

The Social Security Death Index provided no indication that
Tommy Johns was dead, so I kept searching. My colleague Dan
Partridge and I tracked down several dozen people around the
country named Thomas or Tom or Tommy Johns—all about the
right age—but none of them were the right guy. Then, in Octo-
ber 2009, Smith's son, Pat, by now a retired race-car mechanic,
sent me an e-mail: "I found him." They had connected through
a website dedicated to helping people find lost classmates.

Johns was living in the Dominican Republic under the name Tamas Janda, and we began corresponding immediately. He told me that Tamas Janda was his birth name, a fact he learned from his mother's official papers after she died in 1967.

When Janda ran away from home and hitchhiked into Manhattan it was the first of many moves. He ended up working construction in Florida in the 1970s. Then hopped islands in the Caribbean, learned to cook, and opened a few bars and restaurants, including one, No Bones Café, that was written up in *Caribbean Travel & Leisure.* In early 2010, a friend offered cheap rent in a vacant mobile home in Orange City, Florida. So at age seventy, Janda moved again.

In the spring of 2011, I drove down to Orange City from North Carolina to visit Janda. He was waiting for me in his driveway when I pulled up. Janda's white hair, mustache, and glasses set off his dark, outdoor skin and wrestler's physique. It was about to start raining, so we shook hands and quickly went inside his trailer. We sat down at his kitchen table, and over plates of spicy chicken and several Budweisers, he told me his story while thunder rumbled into my tape recorder and rain pelted the trailer top.

I was born in 1940 three days after my parents passed through Ellis Island from Romania or Hungary or somewhere like that. They were gypsies running from Hitler and, you know, true gypsies aren't sure where exactly they are from. My mother was Bertha Lillian Klimko Janda. My father was Joseph Janda. They divorced when I was a baby, and my mother married Lee Roger Johns. He adopted me in 1944, and they changed my legal name to Thomas Michael Johns. That's still my legal name, but I've been going by my birth name since 1967.

My mother drank too much, and later she got into terpin hydrate cough medicine with codeine. My stepfather was worse. He made eighty bucks a week and spent forty on cases of beer and bars. They would fight

all the time, sometimes with broken bottles, knives, and things like that. The cops would come over. We had a coal stove and that was our only heat. There was no insulation. You couldn't have a glass of water beside the bed at night because it would freeze.

I had a lot of problems in high school because we were poor, my parents were drunks, and I wore thick glasses. I got bullied a lot. I was called bookworm *and* four eyes. *I still have scars on my hands where bullies would burn me with cigarettes. When I was around fourteen I decided I wasn't going to take any more shit. I started lifting weights and taking martial arts classes. I went back and kicked the shit out of everybody who had ever bullied me or made fun of my family. Sometimes I didn't win the first fight, so I had to go back a second or third time. But eventually I kicked the shit out of everybody.*

When I was about ten years old my mother got into really bad shape. She was barely making it. I was the oldest of five kids, and I learned to cook on the coal stove. As a senior in high school, they let me only go half a day so I could work and feed my brothers and sisters.

After high school I knew I had to get out of there. But it was painful. I realized that no matter how hard I worked, no matter how hard I tried, there was really nothing I could do for my younger brothers and sisters, not with my parents there. It was a sad situation. So I took off.

Gene had a studio couch and a reclining chair, and that's where I would crash. My job around the loft was to make shelves, organize, and label everything. We never talked about money. I got paid with the roof over my head and there'd be food, booze, and occasionally dope to smoke. Gene drank a lot and he did speed. I never liked the idea of speed.

For my nineteenth or twentieth birthday Gene gave me a Mamiya thirty-five-millimeter camera with a fifty-five-millimeter lens and a detachable magazine. I took pictures with it and one day I took one of Gene standing in the loft—he had a Leica in his hand and his head was tilted. In the background you could see all the corkboards and foam boards with his work prints tacked to them. Gene's cat Pending was in the background,

too. He was a stray alley cat who took up living with Gene. People would ask, "What's your cat's name?" Gene would say, "His name is pending; I haven't made up my mind yet."

One day Gene said to me, "Tomorrow Eddie and Grace are coming by." I didn't know who he was talking about, but it was Edward Steichen and Grace Mayer from the photography department of the Museum of Modern Art. I think it was Steichen's last year there before {John} Szarkowski took over. Gene encouraged me to show them some of my work. I'm a nineteen-year-old runaway nobody with only the clothes on my back and a camera Gene gave me and here come these important folks from MoMA. I showed them some pictures and they wanted prints of my portrait of Gene. It might still be in the MoMA collection somewhere, but my prints and negatives are long gone.

Janda got up from the table to get two more Budweisers. When he returned, he handed me one, and I asked him the question that had been on my mind since the conversation began.

Why did Smith let you stay in the loft for so long?

Janda's eyes watered. He paused, then took off his glasses, wiped his face, and drank a sip of cold beer.

I was a hard-ass motherfucker most of my life, but I'm really a softie.

He paused again.

You have to remember that I was a real poor kid growing up in an environment that wasn't particularly nice, and Gene knew that. He was a tremendously sensitive man. But he was also dead honest: honest to the point of pure pain. One thing he was honest about is that he was a poor husband and father. He didn't fake it. But he was sincerely compassionate and empathetic. It's almost as if there was an eye inside Gene that had to be filled. I don't know how to explain this. Not many people are truly able to understand beauty and pain and ugliness. Most people don't want to be reminded of their humanity, which is inherently painful and ugly. Gene sought that out.

Janda and I spent a couple more hours talking and listening

to the rain. He told me about his hot pepper plants outside his trailer. A few weeks later he sent me several batches of different hot sauces and an envelope full of various pepper seeds.

o

Driving back to North Carolina the next day, Janda's description of the unwanted human image haunted me—the beauty and pain he thought were inextricable, a conjoining that Smith preferred at the expense of himself and those close to him. There is also that thing, however to describe it, that kept me searching for Janda for a dozen years, and the Internet that helped me find him.

DORRIE GLENN WOODSON

Gene Smith is often portrayed as a classic midcentury male artist-egotist, and not without reason. But there was something selfless about his work in the loft building at 821 Sixth Avenue, especially his tapes; there was nothing he could have done with that material, no practical outlet, and as a manner for expunging his passions the activity of recording sound went against his well-known craft. In other words, his ego doesn't seem to have motivated his audio work, which spurred me to reach out in disparate directions far beyond his photographs.

○

One of the loft's original tenants, in 1954, at the beginning of the "jazz loft" era of the building, was the photographer Harold Feinstein, longtime friend and assistant of Smith's. He shared a wall on the fourth floor with the revered Juilliard teacher Hall Overton, who gave private lessons in his loft on side-by-side upright pianos. In 1955, the pianist Dorrie Glenn moved in with Feinstein and in 1956 she became pregnant. Facing loft conditions not suitable for a newborn, Dorrie and Harold moved out

the next year, and Smith moved in, taking their half of the fourth floor next to Overton, facing the street.

Before Dorrie and Harold left, they threw one last dinner party in the loft, and the writer Anaïs Nin attended. Later she captured the scene in her diaries:

> *Last night dinner at Harold Feinstein's. A long loft room, all across one floor, floor uneven with holes. Harold tall and round-faced showing his work. His wife pale and blond, pregnant. In the front of the room all his photographic equipment. In the middle of the room, a double bed. In the back a stove, a table, an icebox. The dispossessed life of the bohemians I knew in Paris. The talk was rich. On the floor above him, live jazz musicians. That night crystallized my vision of jazz music linked to a way of life, another vision of life. It has passed into the bloodstream and separated people from material ambition. It is the only rebellion against conformity, automatism, commerce, middle-class values and death of the spirit. It all made a synthesis, Really the Blues, and Solo, and The Man with the Golden Arm, and The Wild Party. The only poetry in America, the only passion. I am not speaking of delinquency, or the lower depths of Nelson Algren, but a poetry, a heightened state, a search for ecstasy, the equivalent of surrealism. And the equivalent of jazz in writing.*
>
> *Why not pay attention to the artists who humanize, keep the sources of feeling alive, keep us alive?*

In October 2010, I met the seventy-six-year-old Dorrie Glenn Woodson in New York. I mentioned Nin's diary passage to her, and she responded with wry chagrin:

Nin relegated me to pale blond pregnant wife status. She's talking about jazz in our loft all night, and I'm a working jazz pianist and she

totally tuned me out of the conversation. In her mind, the jazz musicians were the men upstairs. It wasn't just the men who made it difficult for women, it was the whole culture of the times, and Nin was no different in my brief experience with her. She was probably an important role model for many women, in that she lived her beliefs and pursued and realized her dreams. Jeez, now that I said that, isn't that enough? I shouldn't be so hard on her. It's just that personally she had never entered my mind as being a feminist. I was living a very conflicted, difficult existence, trying to be a jazz musician, and I didn't see Anaïs doing anything that helped open any doors for me or other women at the time. She did help herself, though, and maybe that was enough.

○

When I met Woodson she had naturally gray hair that was long and free-flowing, parted down the middle and framing her glasses in the style of Gloria Steinem. She was born Dorothy Meese in 1934 on a small farm in rural Pennsylvania near the Mason-Dixon Line; her father farmed fruits and vegetables and peddled them in nearby towns, and her deeply religious mother practiced the dawn-to-dusk farm traditions with dedication and care. The Dorrie Woodson I met was a long way from the farm.

Young Dorothy displayed a touch and dexterity on piano beyond her years. The radio brought Ella Fitzgerald, Nat Cole, and Duke Ellington into her home in a nearly all-white region. She was transfixed. Her dreams of being a professional jazz pianist grew more potent. In 1952, after a talent show in Salisbury, Pennsylvania, eighteen-year-old Dorothy met an African-American bassist and singer in the Herb Jeffries vein. He was from Frostburg, Maryland, and twenty years her senior. They began a long-term relationship, in secret. She gained confidence in her ability to make impressions musically and to generate opportunities for herself. Things seemed hopeful. But she'd grown up without

anyone uttering a word of sex education—and birth control was still illegal, and often unreliable.

I became pregnant in Hagerstown, Maryland, and I was taken in by a Catholic agency that placed me in a private family home. Then they placed me in a home for unwed mothers. I was totally drugged out during childbirth. This was February 1955. I nursed my baby girl for six weeks, but gave her up for adoption because I had my eye on New York City. Actually I'd had my eye on New York since I was thirteen years old. I knew I couldn't manage both music and motherhood. If there'd been decent birth control during this time I wouldn't have had this decision to make. It would be difficult for a man to understand how hard this was. I decided to go for my music. Around this time I met a saxophonist and I liked his last name, so I adopted it. I also changed my first name to Dorrie. I became Dorrie Glenn.

By April 1955 Dorrie was living in Baltimore, working a day job and playing piano at the YWCA at night. The vibraphonist Teddy Charles passed through town with a band booked at the club Dorrie went to every Sunday night. She met Teddy there, and he encouraged her to move to New York. He told her about the loft building at 821 Sixth Avenue where an after-hours jazz scene was developing. A month later, Dorrie arrived at the Port Authority bus terminal, dropped her bags at the local YWCA, and found her way to the flower-district loft building. There she met Harold Feinstein, who lived on the fourth floor, and soon the two were married.

The period from 1955 to 1957 in that loft were two of the most carefree years of my life. My music was in good shape; my music was cared for. I was gigging in the Village, and I went on a well-paying tour around New England with the Sheraton Hotel chain. Then, in late 1956, I became pregnant with our daughter and we moved out of the loft. I gave birth to our daughter in 1957. I enjoyed mothering and I gradually returned to work at local clubs. Harold was working on his photography

and in 1959 he got a job teaching at the University of Pennsylvania, so we moved to Philadelphia. We decided to split up although I was pregnant with our second child. I moved into my own apartment. Our son was born in 1960, and I had both children living with me. That's when the real nightmare began. My gigs were at night, you know, beginning at nine p.m. or ten p.m. So I'd get home at two a.m. or three a.m., and then the babies would be up at dawn. I started having hallucinations from lack of sleep. So Harold and I decided to move closer to each other so parental responsibilities could be shared more easily.

There was unshakable tension between motherhood and developing what I wanted to do most in my life—something that started at a very early age for me—and that was playing music. There must be many women out there whose dreams were squelched or seriously deferred by motherhood. There must be many women out there who spent much of their lives enduring and recovering from unwanted pregnancies. But you rarely hear those stories. Or I don't hear them, do you? It's considered unmotherly or immoral for women to be honest and tell those stories. It has nothing to do with loving your kids or not. I loved mine and I feel like I was a good mother. I'm still close with them today. But it's just a trade-off men don't have to make.

In the early 1960s I began to have some new relationships, and I had two accidental pregnancies that ended in illegal abortions, which were done by a doctor who was an excellent doctor and wanted to help women. I mean, truly, that was his mission. He was a saint. But there was one night I was working at a club after one of the abortions. I thought I was fine and I was back at work. It was a dark club like they all were. I was playing piano and for whatever reason I started bleeding. Before I knew what was going on there was blood all over the back of my dress. I didn't know whether to acknowledge what was happening or just get out of there. I didn't know what to do. There was blood all over the piano seat. I ended up in the hospital where they threatened to not treat me unless I revealed the name of the doctor who had done the abortion. It

was terrifying. I never told them the name of the doctor. Eventually, they treated me. In 1963 I was introduced to the pill and that put an end to my life of ignorance and conflict up until that point.

I mentioned to Woodson that I had documented nearly a thousand people as being part of the loft scene at 821 Sixth Avenue and fewer than a dozen of them were female musicians. Woodson shook her head knowingly.

There are so many stories about what it was like for a female jazz musician back then. It's not just that men didn't want to play with women. The problems were more complex than that. I used to play piano at all kinds of joints, a whole spectrum of joints. At some of these joints it was part of my job to go to the bar in between sets so men would come up to me and buy drinks for me. I was supposed to play good piano and then go to the bar and sell drinks. Can you believe that? I was never much of a drinker, so I'd have six glasses of full drinks lined up behind the piano at the end of a night.

Dorrie later met and married Bill Woodson, a bass player. For forty years she has lived in San Antonio and was active on the jazz scene there until 2007 when she contracted chronic fatigue syndrome. I asked her if she'd ever considered writing about her life. She responded with a comment that reminded me of something Nabokov once wrote about losing a memory after employing it in one of his books:

I've been encouraged by several people to write a book, but I don't want to. Sometimes when something happens and it is so outstanding and you tell people about it, your memory of the original story dims. It becomes a memory of a memory. I don't want that to happen to me.

14

MARY FRANK

I knew Mary Frank only as a figure in a photograph. She was the beautiful, exhausted young mother in the car with her two children at the end of Robert Frank's *The Americans*—the woman keeping their kids fed, clean, and happy on the road, while her husband completed work that would make him immortal in the history of photography.

In 2010 I met her through her cousin Paul Weinstein, who I'd met through David Levy, the former director of the Corcoran Gallery in Washington, D.C. Paul was a businessman and a jazz presenter, Levy told me, and he might be able to help my research in some way. One night, Paul and I were having dinner downtown, and I told him I'd spent the afternoon with the photographer Robert Frank in his Bleecker Street studio, talking about Gene Smith. Paul said nonchalantly, *My cousin Mary used to be married to Robert.* I startled to attention, the small town of New York City revealing itself to me once again.

Mary and Paul's grandfather, Gregory Weinstein, had emigrated from Russia in the 1870s and started a printing business on Varick Street, a business Paul still runs today. After being

introduced by Paul I visited Mary at her sixth-floor studio on the north side of West Nineteenth in November 2010.

Frank's home contained art, objects, and all kinds of materials. The afternoon sun poured through the eight-foot windows—warm, early winter light. Her husband, the musicologist Leo Treitler, remained in his office after a brief, friendly introduction, and an assistant worked quietly on a computer. Squash roasted in the kitchen, and the aroma filled the apartment. It felt like a country house. On the kitchen counter, a Post-it note jotted with blue ink read: "Leo, today sometime, please squeeze in playing me a mazurka or whatever else you think is beautiful." When the squash was ready, she offered me a piece.

Mary Frank was born Mary Lockspeiser in London in 1933. Her mother was a painter and her father a musicologist. She and her mother emigrated to New York in 1940 to escape the war. She began doing artwork in her mother's shadow, and in the late '40s, she studied dance with Martha Graham. At age seventeen, she married Robert Frank and the next year gave birth to their son, Pablo. Their daughter, Andrea, was born three years later. In the mid-'50s, Mary studied drawing with Hans Hofmann, then became an influential sculptor, then a painter. She and Robert divorced in 1969. Neither child, Pablo nor Andrea, made it to middle age. Andrea died in an airplane crash in 1974, and Pablo, who had Hodgkin's, committed suicide in 1994.

Paul had introduced me to Mary as a biographer of Gene Smith. She had memories of Smith, so my first visit was ostensibly to hear them. She told me that Smith often wrote letters to her and Robert from Africa when he was there working on his Albert Schweitzer essay for *Life* in 1954. She used a word to describe Smith that I hadn't ever heard in all my years working on this project: *touching.*

You could feel that everything was a struggle for him. It was touching to witness that effort and struggle.

Mary was generous, playful, and tender at the same time she was understated and exacting. I grew curious about her work, and she showed me her new photographs, which beg for autobiographical elaboration that she quietly dismisses, saying only, with a laugh, *It's much better if viewers of art are asked to work hard.* She told me that having a printer like Paul in the family had made her a better artist—he gave her paper to work on. *Paul's generosity allowed me to draw so freely, without worrying about mistakes. It affected my drawing in a wonderful way.*

As I was packing up to leave, Mary's little dog emerged. *Do you want to see a trick?* she asked. She pulled out a hula-hoop with paper flames taped to it. She held it low and the dog leapt through, delighted, and then back through it from the other side.

When I returned home to North Carolina, I called the photographer, filmmaker, and musician John Cohen, who was making a documentary film about Mary. He has known her since the '50s.

There's something about her, and the only word I can think of is magic, Cohen told me. *It's more than beauty, although there is that. Photographers like Walker Evans, Elliott Erwitt, Ralph Gibson, myself, and others were drawn to photograph her. When she was with Robert, she was equally as fascinating as him, if not more so. That magical, mysterious quality is in her work, too. Her art isn't conceptual; it's not geared for the market. It comes from a deep, subconscious place. There are characters and figures in her work that are still around from fifty years ago, but she's never stuck. The characters mature and evolve. It's a visual language she created on her own. There's feminism and nature and ancient mythology, but to say those words limits what her work really is. There is a tremendous sense of personal biography, and there's tragedy, but it's not spelled out. It's left to the viewer to bring their own biography to it.*

I called Mary to ask her what kind of work she would do next.

I really love drawing from life and I haven't done that in a while, she answered. *I'd like to continue with the series of photographs, work-*

ing with fire, water, and ice. I also have some unfinished paintings, some recent ones and some from many years ago. I'd like to finish the old ones in ways I couldn't have done when I started them. But all of this is conjecture—because, who knows? Decisions are like butterflies. I study butterflies at our country home. Their tongues are like watch springs; they are coils. Butterflies go from one flower to the next flower looking for nectar, extending their coils, testing every flower. I'm looking for nectar, too.

PART VI

A SAMPLE OF SMITH'S PAPERS AND CORRESPONDENCE, 1959–1961

April 19, 1959. A summons from the Supreme Court of the County of New York to pay $456.41 ($3,729.50 in 2017) to Willoughby Camera Stores.

o

June 24, 1959. A receipt for the purchase of 23 reels of audio tapes totaling $40.52. Florman & Babb, Inc.

o

October 17, 1959. An order of 79 books from Marboro Books on Forty-second Street totaling $186.89. Books include *The Art Director at Work*, *Treasures of American Drawing*, *Painting and Reality*, *Learn to Draw*, *Shaw on Theatre*, *Man and Shadow*, *Brecht*, and *Chagall*.

o

November 3, 1959. Smith pawn receipts from Joseph Miller, Licensed Loan Officer, at 1162 Sixth Avenue, totaling $200 for a Hasselblad camera, a 4.5 Biogon lens, and a Canon 4.5 400mm.

o

November 30, 1959. Smith pawn receipts from Joseph Miller totaling $425 for a Canon 3.5, Kilfitt 2.8, Canon Serenar lens, Yashica camera and three lenses, Novoflex lens, Canon lens, and others.

o

January 14, 1960. Letter from Dr. Frederick S. Frank, D.D.S., asking for payment of $401 for dental care. The letter references a phone conversation in which Smith says the family will have to sell the house in Croton so he can pay bills.

o

January 20, 1960. Letter from Smith to George Orick, who had spent the previous year, along with his wife, Emily, trying to help Smith get back on his feet.

> *I hereby terminate your representation of me. From this time you are no longer authorized to act as my agent or representative under any circumstances.*

o

January 27, 1960. Letter from Emily Orick to Smith, written in part in third person, as if a deposition or court proceeding:

> *There is a word for Mr. Smith's problems of the moment: projection. It is not George but Gene who, having made himself vulnerable, must now find someone culpable for his anxiety . . . But George is not your enemy, Gene, nor were any of the others whom you chose to see as your bêtes noir. The hooded figure whose face you can never seem to pin down is only yourself.*
> *The time span gets shorter and shorter, Gene—eleven years*

for Life, *two or three (inaccurate but unerring) for* Magnum, *a year for George—perhaps six months for the next person, three for the next, six weeks, three, a week-and-a-half, a few days, a few hours, a few minutes—then time will run out, and with him all your disguises. You will be left inexorably to face the man who has built so many cases against you.*

○

January 28, 1960. Letter from the attorney Maxwell G. Cutler on behalf of Dr. Frank. Threatens legal proceedings to obtain the $401 for dental care.

○

February 2, 1960. A $500 check from Polaroid to Smith.

○

March 30, 1960. $1,200 loan from Chemical Bank to Smith. Collateral is $10,000 in Equitable Life Assurance Society Policy.

○

May 17, 1960. Legal action against Smith by Olden Camera & Lens Co. on Sixth Avenue for $580.64 in debts.

○

May 25, 1960. The Art Institute of Chicago bought five of Smith's Pittsburgh prints for a total of $250.

○

May 27, 1960. Letter from Fulton Adjustment Bureau about Smith's failure to pay travelers insurance bill.

○

June 12, 1960. Contract for $960 with *Sports Illustrated* for photography, $550 in advance.

○

September 15, 1960. Bill for three months of rent at 821 Sixth Avenue, two months overdue. Total of $195 due to Jack S. Esformes and Esformes Realty Co.

○

September 23, 1960. Walters Electric Supply threatens legal action on $324.75 owed by Smith.

○

September 28, 1960. Letter from an attorney for R. H. Macy & Co., Inc., threatening legal action regarding $2,322.26 (more than $19,000 in 2017) that Smith owes Macy's department store.

○

October 6, 1960. Letter from the City of New York's Department of Water Supply, Gas and Electricity indicating electricity will be disconnected for noncompliance. Letter states, "Feeder to third floor panel is overloaded. Outlet boxes are not securely fastened. Armored cables are not securely fastened. Fixtures missing from outlets. Unused outlets not properly capped. Grounded receptacles not provided for portable tool equipments and heater units. Drop cord pendants are deteriorated."

○

October 7, 1960. Legal action pursued by Walters Electric Supply for $324.72 owed by Smith.

○

On November 28 and December 29, 1960, Smith's daughter Marissa, age nineteen, wrote her father two letters, the first pleading with him to come to her wedding to give her away and to make photographs, and the second asking him why he didn't come home for Christmas. In the latter, Marissa also told him what her sister Shana, age seven, wanted for her upcoming birthday (a new dress) and that her mother needed a new gold wedding band.

o

February 10, 1961. Letter from Sigma Electric Co., Inc., seeking payment of $166.66 and making reference to attorneys.

o

February 22, 1961. Smith subscribed to *Broadcast Engineering* magazine.

o

Countless pawn tickets from 1961.

o

In the early morning of September 25, 1961, when Sonny Clark almost died in the hallway of the loft, we know that Smith packed seventy-nine pieces of luggage for the trip to Tokyo and the assignment with Hitachi. Later that day, Smith and Carole Thomas departed from Idlewild Airport for Tokyo, where they stayed for twelve months.

In October 1961, a woman named Ruth Fetske began organizing Smith's loft and paying bills for him while he was gone.

RUTH FETSKE

On a tape recording Smith made in January 1964, an intriguing argument can be heard between him and his loft neighbor, the bass player from Detroit, Jimmy Stevenson. Smith is forty-five years old, his legend diminished by patterns of failed grandiosity. Stevenson is twenty-four and scrambling for footing in the jazz world.

The argument concerns security in the loft. Smith complains about his equipment being stolen; he questions Stevenson's policy of handing out keys to other musicians. Stevenson responds, exasperated: *When I first moved in here {1961}, it was nothing but a dope fiend pack of rats up here, all kinds of weird people who were up here when I first came up here. I mean, it was like open havoc. I mean, it was ridiculous. And I myself changed the lock on it and ordered all those people away from this place. You know, because there wasn't any door downstairs. You had thousands and thousands of dollars of equipment, and there wasn't even a door downstairs to lock at night.*

The argument is heated, but when the telephone rings or people stick their heads in the door and interrupt them, the two men instantly turn civil and friendly, clocking in and out of the

argument like Sam Sheepdog and Ralph Wolf in the Warner Bros. cartoons.

A few minutes later, Stevenson made this comment: *You had given keys to Will Forbes and you had given keys to that other woman—what's her name?*

Smith responds: *Well, if there's anyone in the world that I trust, it's Ruth. The only person I thoroughly trust besides Carole at this moment is Ruth Fetske.*

Fetske wasn't mentioned in previously published articles or books on Smith. In his archive, copies of letters exist that she wrote to accompany checks to people that Smith owed money. Otherwise, she was a mystery.

Using public records, I tracked down Fetske in October 2004. She was eighty-two years old and living alone in a rural, wooded setting on the bank of the Connecticut River near Haddam Neck, Connecticut. I made a trip to visit her with my colleague Dan Partridge, who recorded our interview on video.

Ruth Fetske was born Ruth Bumgarner in Rahway, New Jersey, in 1922. Her father was from Wilkesboro, North Carolina, and her mother migrated to New York from Hungary when she was six or seven years old. They met in New York when her father was in the army, and went on to have three daughters.

Ruth married an engineer named Bill Fetske, and they lived in various apartments in New York City over the years. In 1951, they bought property on the river near Haddam Neck and spent weekends and summers there. After she retired and her husband passed away, she moved to the river house permanently.

It was a beautiful New England fall day, so we decided to do the interview on Fetske's wood-planked deck outside the house. Wearing a bright red sweater, Fetske sat down and began telling us how her life intersected with Smith's.

I was in my late thirties in 1959 or 1960 and working as an account

executive for an advertising agency when I decided to take a photography course. I had to do a lot of editing of photographs for fashion ads in my work, and I figured the more I learned, the better off I'd be. The first course I took was with Alexey Brodovitch, who was for many years the art director for Harper's Bazaar. *He taught a course about what you look for in a photograph. And, of course, his end goal was to sell products.*

After that course was finished, I saw that "W. Eugene Smith" {her emphasis} was going to give a course called "Photography Made Difficult" at the New School. I had known and admired his work from Life *magazine. So I signed up, and that's how I met Gene.*

Of course, Gene's course had nothing to do with selling products. {Laughs.} The way he introduced himself to the class, he just got up and read something that he'd written about the first time he'd gone out to take a picture after his war injuries had healed and the results were The Walk to Paradise Garden. *He was not a good-looking man, and whatever injuries he had during the war hadn't improved anything. He was a physically ugly man. The back of his nose and the back of his sinuses were injured in the war and he had a postnasal drip as a result, I guess. He told us that when he bent over the camera he had this, you know, profusion of nasal fluid that dripped down onto the camera. Finally, he got what he thought was the right photograph, which is the one everybody knows today. That's how he introduced himself. That took the entire first class meeting.*

The next class—he brought us to his loft, which was a disaster. There were prints all over the place, dust was this thick (using her fingers to demonstrate), *and there were negatives and things like that kind of spread all over the place. It was a period of time when he also was painting. Have you seen any of those terrible paintings? Oh, my, he was a terrible painter.*

Anyway, that's how I met Smith and his loft. And, you know, I've always been Miss Helper, so I started helping Gene. My office was on Eighth Avenue and Thirty-fourth Street. My husband, Bill, and I had

an apartment at the time that was on Twenty-fifth between Second and Third avenues. So Gene's loft was kind of right in the middle. It was easy for me to stop by there coming and going.

Let's say Gene had to mail something, a photograph or something, and he didn't have any money: I'd get a call from the receptionist saying, "There's a Mr. Smith here to see you." I'd go down, and if he needed stamps, I'd give him stamps, not from the office but my own personal stamps. Or I would say, "I'll mail it for you."

My husband, Bill, was an engineer and he had projects all over the world—bridges in Peru, floating docks in Ohio, wells in Texas, a synthetic plant in Philadelphia. He was a very talented man and we had a good long marriage, and we really loved this house here on the river, but we never had enough time to have any kids. If Bill was busy or out of town, I would go over to the loft and help Gene.

When Gene went to Japan in 1961, I just made it my business to pick up the mail while he was gone and to see that we fended off the {laughing} monetary demands in some way. I wasn't his bookkeeper or his lover. I was just a photography student in my late thirties, with no kids, looking for extra things to do to keep busy and help out. Gene was in awful shape financially. I just helped him organize things. Somehow we managed to stay ahead of the game until he got back from Japan.

Before he left for Japan, I said, "Gene, you know, you're going on a long trip. You have to do two things for me. You have to make a will. You have to leave your photographic assets to somebody of consequence, somebody who would be responsible." So he made me his power of attorney while he was in Japan.

Anything that came in the mail, any kind of a check, I could deposit. And every once in a while, there wasn't any money, and I put some of my own money in. You know, what the hell? {Laughs.} And so, when he came back, the place was still there. I just made sure that, financially, they did not close out his loft.

And the other thing I did for him—he was always complaining

about how he couldn't find the negatives or this or that. So, I said, "I'll give you a system. You know, it's very easy. You have numbers. The first number is the month; the second number is the date; the third number is the year. And if you shoot more than one roll, you can go 'a,b,c,' or you can go 'one, two, three' at the end. If it's going to be color, you can just put a 'c' in front of the first number."

Fetske's organizational system was the starting point for professional archivists when Smith's materials arrived at the University of Arizona just before his death in 1978. Some of her original handwritten notes survive.

I asked Fetske why she volunteered to help Smith to this extent.

I was willing to help Gene, I think, because he was talented. And he was sick. He was very, very sick. When you see somebody with such great talent—and he had enormous talent—who kind of couldn't get out of his own way, you wanted to help him. All of us—everybody who was helpful—were all photographers ourselves, and so it was a pleasure to help. And I think Gene was a great salesman of himself. There were a lot of people who don't like him because they felt they were used. But nobody can use you if you don't stand there and be willing.

Gene was also very bad about feeding himself. He had better things to do. So usually, I would stop across the way, and because his teeth were so bad—you know, his whole face was a mess—I would sometimes take up a piece of Boston cream pie or something soft, you know. He would say, "Oh, I don't need this," and then gobble it up.

He was always in debt, but somehow the money always came when he needed it the most. He did a series of photographs for Jack Daniel's in Tennessee. I don't know what his financial arrangement was, but I know that it helped him. One of the men around the loft at the time offered to drive Gene down to Tennessee. I think his name was Phil {Dante}. But first, Gene had to get his cameras out of hock, and I don't know how he finessed that. Maybe he gave prints to the pawnshop owner—I don't know. I just don't know.

Then he got a call to go to Japan. He was very excited. And again, he had to pull his cameras together out of hock. The money he got from Hitachi in Japan went a long way. I don't know how much they gave him but for a while he had some money. He bought a lot of expensive art books and a lot of taping equipment.

While he was in Japan, there was a lady—her name was Jas. Do you know her? (It was Jasmine Twyman, the live-in housekeeper at the Smith family home in Croton-on-Hudson.) *She called me, and I couldn't help her because I didn't have any spare money. He had this place up in Croton-on-Hudson, and his wife and children, I think, were there. And, of course, he was not very good about sending them money. I don't know how they lived. He knew that Carmen and Jas were calling me, looking for help, and he—you know, it just was not critical to him, just not important. Whatever he was doing at the time, it was more important. I just don't think he wanted the responsibility.*

Fetske paused to note the sounds of a bird in the trees near the river. *That's a pileated woodpecker. They're big and they're gorgeous.*

We could hear rhythmic waves of boat wake lapping on the bank of the Connecticut River on the south edge of her yard.

In the first cool spell of winter, said Fetske, *there is a thin skin of ice that forms up along the edge of the river, and it tinkles. It's the prettiest—it's something you should record, really. It's just beautiful. There's a lawyer I know that used to live along the river, also. And he said to me, "You've heard it, too, Ruth?" And I said, "Yes!" Every year, you wait for that. It's only the first {freeze} because it's just a shell of ice. It's very light and tinkly. Once the ice gets thicker it doesn't make the same sound.*

There was a tap on the door of Fetske's house and in walked an elderly man with a tiny dog in his arms. Ruth introduced them as her neighbor George Peete and his dog, Ruggie. She kindly told Mr. Peete that we were busy with the interview and asked if he could come back later in the afternoon. After he left, Fetske said:

Ruggie's a story in herself. She ran away from home when she was only—I don't know—six months old. I was driving through Middle Haddam, and I see this little bitty dog running down the center of the road. I said, "She's going to get killed." I couldn't stop because there were people behind me. I finally stopped at the post office a couple of blocks away.

I went inside the post office and mentioned to the girl that I had seen this little dog. And she said, "Oh, there was a man here. He had the little dog. He picked it up off the street." And I said, "I know where that little dog belongs." And I got his phone number from the girl—he had left his phone number, and he had taken the little dog with him.

On my way back to my house, I saw a lady out in the yard, and I knew she was looking for her little dog. So, I stopped and I said, "I know where your little dog is." I gave her the phone number. A few days later, I met her at the post office, and she told me that they really didn't want to keep that little dog. They were going to give it away for adoption. And I knew George Peete wanted a little dog, so I convinced him he should adopt this little dog. So we've kind of kept in touch. Her full name is Rug Rat, but she goes by Ruggie.

Fetske leans and cranes her neck in a faux-comic attempt to look around the corner to make sure George isn't still standing there.

Where were we? Gene Smith, oh, yeah. He should have been born in the era when very wealthy people underwrote and subsidized talent, like they did in the Renaissance period in Italy.

He had a problem. He had a lot of problems. He was a perfectionist, and nothing was ever quite good enough. When he made a print, I'm sure he felt if he just had one more hour, one more day, one more week of deadline, you know, having to meet a deadline, he could do better. He had a psychosis about perfection. I don't know where this came from.

He and I had discussions. He said, "Ruth, there is nothing like— there's no such thing as perfection because it can always change." And I

said, "Gene, let's say you take a point in time. At this point, you've done something; you've made a print. A millisecond before, a millisecond after, that doesn't count. But right at that point, that is perfect for that moment."

We never could agree on that. It was one of the discussions that we had. But his problem was that he couldn't let go of things, he always wanted everything to be better, and it must have been terrible for the editors at Life. They must have hated his guts.

And something else . . . I think when Gene went to take a photograph or to fulfill an assignment, I think he went with a complete picture of what he wanted to achieve. Like when he went to Africa, you know, for Schweitzer, I think he knew exactly what he wanted, and by Jesus, he stayed there until he got it. This must have been very difficult for the editors. And he wanted to write his own copy. He wasn't that great a writer, either; he went on and on and on and on. And the one thing that he was able to complete was—it was Popular Photography that did the Pittsburgh story, was it? God, that must have been a pain in their neck.

I think he was a man divided in half. I think fifty percent of his self felt that he was like a god, and the other that he was nothing. And I think he fought with himself mentally all the time, and he had to keep proving one side against the other.

When he was on his way back from Japan, the phone rang in my office, which had moved up to Rock Center, and the operator said, "Would you accept a collect call from Gene Smith?" He was on a freighter, I guess, coming into New York, and could I meet him on Friday? I said, "No. I'm meeting my husband to go to the country," which is this house we're sitting in now. The next week, I went to give him back his keys and so forth.

I mentioned to Fetske that she smiled much of the time she was talking about Smith: Oh, sure. My memories of him are fond. He just couldn't help himself. He wasn't a mean person. I just—everything was a challenge to him, everything, just getting up in the morning, I guess.

It was now getting to be about two o'clock in the afternoon

and Fetske had planned to feed us lunch, so we moved to the kitchen, where she laid out cold cuts, condiments, fresh rolls, and a pie for dessert.

Fetske told us more stories from the years she and her husband spent here along the river. I listened and kept thinking back to her story about helping save the little dog, Ruggie, and remembering that when I began my research on Smith in 1997 I had a conversation with Smith's first biographer, Jim Hughes, who called him "a junkyard dog."

After lunch, Dan and I packed up to leave and we drove two hours through gorgeous countryside back to our lodging in Hillsdale, New York. I was moved by Fetske's spirit and generosity, which seemed so unconditional. She was so content. As I was writing her chapter of this book, listening to the recorded interview with her and reading my original notes, I felt compelled to give her a call. I wanted to tell her what I had just written. As I feared, her line had been disconnected, her number no longer in service. I wonder who lives in her house now, and if they notice the tinkling ice.

HALL OVERTON AND CALVIN ALBERT

The fourth floor of 821 Sixth Avenue was divided into two lofts by a temporary plaster wall. Gene Smith had the front, his windows facing Sixth Avenue, from 1957 until he was evicted in 1971. The musician and educator Hall Overton had the back, from 1954 to 1972. Over the fourteen years of shared time, Overton would sometimes cover rent when Smith was broke, and Smith would type long, single-spaced letters to Overton rationalizing his delinquency. Here's the opening of one letter dated June 19, 1958, which was near the end of Smith's Pittsburgh odyssey.

> *Dear Hall,*
>
> *This is the morning of being nearly conscious enough to survey as wreckage—myself, and the fragmented, lifeless shiftings and settlings of my revolution. Revolution which I believed was not for destroying, but which would bring myself and a few others to a new and fertile ground.*

Then six paragraphs later:

My promises broken to you, were not an evasion—and with deep sorrow I am appreciative of the pain which I left hanging as a situation upon you . . . But grimly, my first concerns in these days are going to be those most in need of considering, rather than those most in power with a way of enforcing pressure. I am deeply chagrined that I have left you in this spot—and I have not intended being evasive with you. It was two-fold and many creased—my one way, as long as I was locked in this last relentless climax to the Pittsburgh project, to raise the money for you alone and not for all the others pressing down on me, not even for food, was a one way choice of a pawning of equipment.

The musician Bob DeCelle copied musical charts for Overton before getting a full-time job as copyist and archivist for the New York Philharmonic. During an interview with him at his home in Brant Lake, New York, on October 2, 2004, he offered this memory:

Hall got pissed off because Gene Smith owed him a couple of months' rent. And Hall said, "I'm going to fix him," and he knocked at the door and he banged at the door. And Gene didn't answer, so he figured he was out. Then Hall got out a hammer and he hammered and nailed the door shut. But Gene was in there. And you could hear Gene wailing, "Let me out of here!" Oh, man, there were some wild things happening in that place.

○

On May 23, 2005, I interviewed a psychiatrist named Dr. Baron Shopsin by telephone from my home in North Carolina. I found my way to him after a tip from the photographer Will Faller, a former assistant to Smith. Faller told me that in the early 1970s, Dr. Shopsin had practiced with Dr. Nathan S. Kline, the famous psychiatrist who treated Smith for decades. Faller knew this

because he had sought treatment for his addiction problems from this practice after encouragement from Smith. *Baron Shopsin saved my life,* Faller told me. *He might be able to tell you something about Gene. I think he's still alive and living in Florida.*

I found Dr. Shopsin living in Ponte Vedra Beach, Florida, and wrote him a letter. A week later we set up a telephone call. When we talked, his words sounded prepared:

Nate {Dr. Kline} was one of the only doctors who would treat people who drank like Smith. Medication can add to problems for people who drink that much alcohol. Nate regarded Smith as a genius who was very troubled. He just wanted to help him make it along. By the time I knew Smith he looked like a shell of a person. He was only around fifty years old but a very fragile human being, emotionally and physically. There were pathological reasons for Smith's behavior. It's an obsessional thing that's hard to explain in anyone that has it. His obsessions were very costly, very time consuming and draining for him and others around him. He never found a way to turn them off. He and Nate tried everything. The tapes he made in his loft were the product of a troubled mind. There's no way to explain that degree of activity otherwise. He was driven mad by his thoughts, which were obsessive beyond reason and treatment.

This sounded like a summary to me and I had a hard time going deeper. The rest of my conversation with him focused on how to gain access to Kline's medical records for Smith. He pointed me in several directions, all of which, he admitted, would probably be futile. He was right. I later learned that Kline sold his private practice and the files were shredded.

Then, casually, as we were winding down the conversation, Shopsin asked, *Did you know Smith was bisexual?*

No, I didn't know, and Dr. Shopsin wouldn't elaborate on his comment for me. In subsequent interviews with various Smith associates, I would find ways to bring it up, and nobody could or would confirm it. A few people said things like, *Hmmm, that's*

interesting, that had never occurred to me, but I guess I can see it. But nobody could offer anything more than speculation. If it were true, it could add nuance to Smith's relationship with Hall Overton.

○

Overton was a dashing, six-foot-four suit-and-tie man who, on first glance, seemed out of place in the squalor of 821 Sixth Avenue. After carrying stretchers in combat in France and Belgium during World War II, he taught theory and classical composition at Juilliard and, later, at Yale and the New School for Social Research. His wife, Nancy Swain Overton, was a successful singer, first in a group called the Heathertones and later in the iconic Chordettes, of "Mister Sandman" fame, and they shared a nice house in Forest Hills with their two young sons, including one, Rick, who became a successful comedian.

Overton was revered and beloved as a teacher and arranger. In several dozen interviews I conducted with musicians who worked with him—among them the composer Steve Reich, the saxophonist Lee Konitz, the vocalist Janet Lawson, the French-horn player Robert Northern, the conductor Dennis Russell Davies, the pianist Marian McPartland, and the composer Carman Moore—the reports were consistent: Overton had a unique ability to find and nurture qualities inside other musicians rather than impose his preferences on them. His signature was not having one.

From Thelonious Monk to Steve Reich, the range of Overton's behind-the-scenes influence may be unsurpassed in the American music annals. But he's not really part of those annals today, in part because he seemed to care very little about acknowledgment. He was happy behind the scenes. He preferred the obscurity of his studio loft to the hallowed halls of Juilliard. Musicians hiked the stairwell at 821 Sixth Avenue at all hours

for private lessons and experimental jam sessions with Overton. His charm and lack of self-promotion helped earn their trust.

But there was a toll. His blend of skills made it hard to find a home. *I think Hall stood alone in being somebody who was a {classical} composer and a professional jazz musician and someone who really had a place in the jazz community*, said Steve Reich, who studied with Overton in the loft once a week for two years beginning in June 1957. *I think he was totally unique . . . which means it was kind of a lonely position to be in. There was no place in the academy for a man like him and the bureaucracy wore him down. The weight of Juilliard killed him.*

Overton died of cirrhosis at age fifty-two in 1972.

○

On March 3, 1961, Smith rolled his tapes and caught himself in this conversation with the photographer Bill Pierce and an unidentified man.

Smith: *We'll import him for a jazz session downstairs.*

Pierce: *You should be here when he's here, it's quite something . . .*

Man: *They don't play it over there like they do it here.*

Pierce: *Well, they don't play it here like they play it here. You know, very relaxed.*

Smith: *Relaxed, but some of the best jam sessions, and they're not happening very often. Next door at Hall's, when he has sessions: One, he has very top musicians. Two, he's one of the most learned of all connected with jazz and music. He teaches at Juilliard. He's a magnificent jazz pianist. And among other things, he hooks the other characters into the line of completing something, which for most of 'em . . . they kind of fade away, and you know, he has a beautiful . . . he has a way of controlling musicians to make them work right. If the drummer is lagging, he has a way of forcing him around with his playing, somewhat decently, and few people play as well as when Hall is driving them on. Which is very impressive.*

Man: *Who is Hall?*

Smith: *He guided the orchestration for {Thelonious} Monk, for instance. He also does operas and symphony work and in other words, he's extremely talented, mainly as a teacher, now. But I've never heard one of these jazz musicians that wouldn't pass his door at all without stopping. And that's very true, whether it's been Zoot or Mulligan or anyone else, it's always "Gee, I've gotta study with that guy someday." It's always so amazing because his piano playing is almost too polite and quiet in a way. But he has a tremendous way of urging other musicians on.*

o

Gene Smith and Hall Overton shared more than a wall on the fourth floor of a shithole in the wholesale flower district. They were both from modest parts of the Midwest, Smith lower (Kansas) and Overton upper (apple farm country in Michigan). They had meek fathers and powerful mothers. They witnessed carnage up close in the war while not being armed, Smith as a photographer and Overton as a stretcher carrier. They were riddled by insidious disdain for their employers, Smith for *Life* and Overton for Juilliard, and they retreated to the Sixth Avenue loft building, leaving wives and families in much nicer homes outside Manhattan. Both men had deep and natural creative passions and charms that drew men and women to them. And both men drank themselves to death in their fifties.

There are a number of photographs of Overton by Smith, including one that Overton used on an album cover, and there are many tape recordings by Smith on which Overton is present. What's captured is the sound of Overton playing piano or his voice in rehearsal and instructional settings with other musicians. Amid Smith's 4,500 hours of tapes, there are scant recordings of the two men conversing despite them sharing that fourth floor the whole time.

I met Overton's widow, Nancy, twice at her home in New Jersey, and his two surviving younger brothers, Harvey and Richard, at their homes in Chicago and rural Oregon, respectively. Each of them rarely visited the loft. I needed another source to understand Overton's life there. I had learned that a humpbacked sculptor named Calvin Albert had been his closest friend from his days as a young student until his death.

I tracked down Albert in 2003. He was eighty-five years old and living alone in a community for seniors in Margate, Florida, a town just northwest of Fort Lauderdale.

I wrote Albert a letter, followed up with a telephone call, and learned some of the basics. Born in Grand Rapids, Michigan, in 1918, Albert endured a rather brutal childhood and youth. His parents divorced when he was eight and his mother put him in an orphanage while she took a job in a different town, visiting him only every other weekend. Each of her visits ended with a sobbing separation. Calvin was then moved out of the orphanage and into a home with strangers in a different town. A few years later, his mother returned to live in Grand Rapids and they moved in with her mother, his grandmother, and his aunt.

Then at age twenty, Albert was diagnosed with an untreatable, degenerative spinal disease that left him with a significant and painful hump. His whole life was marked with pain. Through it all, he taught sculpture at Pratt Institute in New York for several decades. After retirement, he and his wife of sixty years, Martha, moved to Florida from New York to be nearer their daughter. Martha had passed away a few years before I reached him.

I knew I'd only get so much from Albert on the phone. His volunteer social worker, Winnie Connor, answered most calls because Albert was confined to very slow movements in a wheelchair. She encouraged me to visit and said that giving Albert an ear might be good therapy for him.

I flew into Fort Lauderdale–Hollywood and drove to Margate on August 20, 2003. Albert was happy to talk about Overton. Immediately, I learned something new. I had figured that the two friends had met in Grand Rapids, because Overton had grown up there, too, after being born nearby in Bangor in 1920. That wasn't the case. They met in Chicago, where they were attending art and music schools, respectively. Albert spoke slowly with purpose and care, surprised and grateful to have an opportunity to talk about his old friend in a deep manner three decades after he had passed away. Albert had been thinking about our meeting for a couple of weeks and when I arrived he was eager to carry the conversation.

After Martha and I got married, one of the first people I met was her girlfriend, her closest girlfriend, who was a classical pianist. She showed up one night with this tall guy, Hall Overton, who was one of her classmates in music school. We became just fast friends. All through the war he sent me letters with little drawings on them. I asked him what was the worst part of the war. He said it was that he was six foot four and he could never dig a trench fast enough to get himself, all of himself, in. So it was {laughs} harrowing.

In 1945, I had my first gallery show in New York and we decided to move there. Hall had returned from the war and had already moved there. I remember we went over to his place and he cooked us a big meal. He liked to cook. In a short time, he became a teacher and I became a teacher, so that friendship just went along all the way. There were a lot of parts about the relationship that sort of weren't healthy. Most weekends I'd spend with him down at the loft. His wife would be home and my wife would be home and, thus, we had dates or something.

In the loft, you know, that building, the most amazing thing was Eugene's studio. When you come in, there was an immense pile of junk, you couldn't believe how much junk, and there was a path going from the door to the back, with junk piled up on both sides of the path: cameras,

film, and everything. You'd think, my god, how does he live in there? He had a girlfriend that lived in there and you'd think, how can she stand it? I just never got used to seeing what a complete and total mess Eugene's studio was.

I was a terrible student and I was a wonderful teacher. I had the greatest ability as a teacher. No matter how bad the rest of my life was and how painful, or whatever, I got in the class and it was just wonderful. The kids all felt that way, you could tell, because no one skipped. Hall and I would go to Chinatown, usually on Friday nights, and we'd walk down the main drag, a street in the village. We seldom could walk two or three blocks before one of us would have a student come up and talk to us.

You know, when you spend so many years talking with someone—it was thirty years for me and Hall—you can't remember any one particular conversation. We had these long, long dinners, long conversations, and Hall's pint of scotch on the table, eating lots of Chinese food, and very elaborate and heated discussions about the art world and where we were and so on.

Hall got very interested in going to see my therapist, which would have been a great idea except that Hall lived way uptown and this guy was over in Brooklyn, even from my house in Brooklyn it was a long ways to this doctor's house. So Hall didn't keep it going, and that was too bad because he just didn't bump into the right doctors. It didn't work out for him. He always found a way of continuing drinking, but he knew his liver was bad for a long time. He drank himself to death, and he knew it was happening.

Hall wasn't a happy man. Being in the army may have been just overwhelming—for some people seem to go through it and other people I think were just beat up by it. But he would have to be very depressed to drink that much. But, uh, he went on drinking and things he did, uh, if he had gone to a real analyst, you know, he might have lived a little longer.

I asked Albert about Overton's teaching, about his preference for teaching at the loft rather than Juilliard: *As years went on,*

Hall began to do a lot of private teaching. What he would do is, the girl he thought was the most possible—that he liked the most, he'd make her his last student over the day, so they could have a drink and sit around. That became a big part—a big part—of his life. People, girls in particular, would do a lot of things that they really didn't want to do, sexually, because it would please a man. Hall had a vast appetite for that. Hall was a very smooth operator with people and in many ways that worked out perfectly for girls and so on.

The real thing it took me many years of knowing Hall to begin to understand—I think he was really, uh, ambidextrous—not gay, but I think it was always there. It was just an observation. When I, when I came to New York he was living with an older guy and I'm sure he was gay, but, uh . . . that was never brought up.

One time his father came to visit and here's this little meek man and Hall's mother was big and dominating. That was an eye-opener. It gave me a real kind of clue to see him and his whole ambivalence, I think, about sex. I think it was probably from this rough, tough mother. It was such a big part of his life, the girlfriends and everything, and it was elaborate. I really didn't know anybody else that cared as much about that {sex} as Hall did.

Whatever it was, uh, I think it led to his sexual confusion of a certain amount. That's just my opinion, based on nothing, except I've heard a lot about that—that people that very often tended to be gay will be very macho and have a lot of conquests and how long they can do it and how high they can do it and all, all sorts of things like that. This one time he had this wild night and the next day he had these two big sores on his knees, from banging around for hours.

Albert paused as if he wasn't sure he should be saying what he had just said. Then he changed the subject abruptly: *The end of Hall's career was so wonderful, in a way. He had written this wonderful opera and Juilliard put it on with all the trimmings—big elaborate sets. It was very beautiful. The main part of the opera was Huck Finn*

and Tom Sawyer floating downriver in the barge. The opera has beautiful love songs. I thought it was a very ingenious way to portray the relationship of love between two men. It was just very beautiful opera. Afterward the Sunday paper had a big sketch of him. It was at least half of the whole music page, with this great sketch that somebody had done in honor of Hall. It was a wonderful tribute.

Only a few days later, he came over to Pratt to lecture. People knew he was my friend so they had him come over and lecture and we went out to dinner. The next day he just dropped on the steps of Juilliard, spitting up blood. He was in the hospital for quite a long time but, painfully, you know, you could hardly talk to him. His passing made a big fuss, because he had been getting more and more well-known. That was a drastic ending, but he had that great opera.

Albert was growing weary and we decided to break for the day. I returned the next morning and asked him to tell me about his own life and work. I was curious to learn more about the background of someone who would become Overton's closest friend.

My dad moved us to Chicago when I was about five. He opened a real elaborate nightclub, with an orchestra and a grand piano and pretty girls. I think it just failed completely. He lost everything. Then, in 1926, he just left me and my mother and that was it. I was eight years old. My mother came from a family of five girls and their parents were born in Europe, so I don't think she had any practical skills, except she was a milliner of some sort. So after my father left, we went back to Grand Rapids and she put me in an orphanage, a Catholic orphanage, and she got a job in another town. I think she was running a hat department in a department store.

I was the only Jewish kid in the orphanage so on Sundays all these people, nuns in black and all the kids, they all marched to church and I sat in the window of the orphanage by myself. That was one vivid memory. The worst memory of that is when my mother left me there. I was eight years old so I was old enough to know what was going on. I just

screamed and yelled bloody murder. She gave me an ice cream cone or a lollipop or something. Then she got on the streetcar and I just chased after it and I actually caught up to the streetcar and got on it when it stopped. So we went through all that again. See, the sad part of my life comes up pretty quick.

As a very small boy I started working with clay. It was the only thing I could figure out to do ever since I was very young. I had this ability and it was very strong and it became the sort of thing that people always thought about, whoever was taking care of me. What about Calvin? Just give him some clay and he'll just stay there and be fine.

When I was about twenty years old I got sick with pains in my back. I went to a free clinic in Chicago and they ended up sending me to the Mayo Clinic in Minnesota. Well, when I got through with all the tests, they called me and told me it was spondylosis, which means your back is going to degenerate and fuse one vertebra at a time, and it is going to take twenty years. I was in a complete nightmare. I could get up and work and run around. But three hours of sleep and I would just wake up screaming.

My wife, Martha, she knew I was sick, but she decided to marry me anyway. She made most of the decisions back then. So she would get up every night and I had a big thing with hot bulbs that she put over me, but you know, that doesn't make you feel any better—it's just hot, and you still have this terrible pain.

The doctors treated me with everything that is more dangerous than the disease and nothing, nothing makes any difference to that disease. Absolutely nothing. I even went in the hospital and they stretched me on a rack, and they put some weights or something on me to try to straighten me out. I was there ten days on that thing. Doesn't make any difference. Just makes it more miserable. Nothing made a difference. By the end of twenty years you're completely fused, you can't move anything. I thought, "That's it." But the pain goes away and you begin to get a different pain because you're so bent out of shape that the muscles are always wrong and pulling wrong so you kind of gradually make a transition into that. So

I've been in a lot of pain all the time and it impacts everything I do. I've been physically vulnerable.

Albert and I decided to take an hour break while Winnie helped him with his physical therapy. I drove my rental car to a convenience store and picked up a twenty-four-ounce Budweiser. I found a vacant parking lot and sat in the rental car and listened to one of Overton's string quartets.

Back at Albert's house, we renewed our conversation and I asked him about the impact of living in so much pain for so many years. He immediately returned the conversation to Overton. He'd been thinking about this story during our break. It was something he wanted to tell me.

We had one wild evening in that Chinese restaurant. Hall and I were sitting and there were two gentlemen in back of us talking. Well-dressed businessmen. I couldn't see them, my back was to them. But they were extreme, super-right-wing, I guess. They were talking about the Jews and Communists, and the homosexuals, all the time. Hall and I were talking, and at one point I couldn't see Hall, I just saw red. That was the only time in my life that I did this—I took the sugar container, unscrewed the top, and very deliberately poured the whole thing over on this guy's head. I mean, all this sugar. When I did that the other man, who was very small, jumped up to hit me, and Hall stood up, you know, six foot four. Nobody got hit because they were scared of Hall. It was very dangerous for me because with this back condition, if I were put in jail or something, I'd be horribly uncomfortable, in pain.

It was the only time in my life I lost my temper like that. But there's a lot of anger with, you know, all of those things that I went through. I may have learned how to cover them up but underneath I . . . I'm dangerous {laughs} to some extent. Also, {if} I'm honest I'd say that Martha and I actually didn't love each other at all, even though we were married for sixty years. Getting married to her was one way of me dealing with all the problems.

The shrinks, they all said if it wasn't for my art I'd be a dead-end kid. It's the reason that when I was a kid they could always put me up in my room with clay and I'd stay there and not bother anybody. It worked out great for everybody and I was, as far as I know, happy.

I think it's very strange to live, now that my wife died about ten years ago and twenty or more years since Hall died. It's very strange. You keep going. Everything has changed so much in these last ten years that it really gets to be very strange. I feel very, very old. But it's not all sad. I outlived my wife and everybody else. It's really very . . . ironic.

OVERTON AND THELONIOUS MONK

The photography world thought Smith had ventured far off base when he quit *Life,* launched a quixotic project in Pittsburgh, left his family and moved into the loft building, and began making audio tape recordings. The impression stuck. In 2002, an elite museum curator chided me: *You still trying to listen to all those tapes of cats meowing?*

There *are* many hours of cats meowing on Smith's tapes, and other bizarre oddities. And the sheer volume of the collection was an obstacle to preserving them properly so we could hear them for the first time. In no small part, my motivation came after spending two weeks in Arizona picking through the dusty reels with Smith's chicken-scratched labels and numbering them 1 to 1,740. I noticed Thelonious Monk's name—usually just "Monk"—jotted on thirty-one of the reels with dates from 1959, 1963, and 1964. In Smith's 5 x 7 work prints, one can see Monk and Overton working together by themselves in the loft, wearing suits and ties, smoking cigarettes, and evidently talking while sitting and standing at Overton's side-by-side pianos. The thought of having surreptitious, behind-the-scenes recordings of Monk—one

of the most mysterious musicians in American history—talking about his music proved irresistible.

○

In early 1959 Monk and Overton spent three weeks arranging Monk's tunes for a tentet to perform at what became a historic concert at Town Hall, the first time Monk's music was ever performed by a big band. From private conversations between Monk and Overton to full band rehearsals in the loft, Smith's tapes provide rare access to the exacting creative process and humanity of a musician who had become more myth than man.

Monk: *Those three arrangements are crazy. I like 'em.*

Overton: *Yeah, I do, too.*

Monk: *I like 'em. We got enough to start a rehearsal, three arrangements, you know?*

Overton: *Sure.*

Monk: *If {the band} did one arrangement a day, that would be a motherfucker. Boy, I tell you, they're going to sweat their balls off on that, uh, "{Little} Rootie Tootie." It's gonna be a hard one for them, to get that clean, all that phrasing clean . . .*

In 2008 I visited Monk's French-horn player, Robert Northern, at his home in Washington, D.C. *I think it was Hall who called me {to join Monk's Town Hall band},* said Northern. *Monk spoke very little. He would've never picked up the phone and called me. Overton called me and said that we were preparing for a performance. I asked him a little bit about the music. I knew it was going to be really interesting and a challenge. I knew I was going to be playing with some of the musicians I had always admired. So I didn't hesitate. The only thing that I did hesitate about was that rehearsals started at three a.m. That was the only time that everybody could make it. It was after the clubs had closed. Everybody {in the band} was playing some nightclub somewhere, you know, Birdland or the*

Royal Roost or something. So, between two and three, people began to congregate in Hall Overton's loft. And by three thirty or four we were well under way. And we were there until seven or eight in the morning rehearsing. I don't think it would have been the same had it been somebody less than Monk. This was an occasion nobody would want to miss.

Monk: *{We} make them work on that all day, you know . . . one song, you know. {It} don't make no sense working on a gang of songs if you don't play nothin' right.*

Overton: *You're lucky if you get it in one day . . .*

Monk: *I've seen cats where they bring the whole book down— like they run the book down—like they playing on the job, and they still don't know shit. Nobody still can play nothing, you know? We can take one arrangement and run that down, and learn that, you know?*

Overton: *Sure.*

Monk: *One a day.*

Monk's personality, judged by the workaday world—or even by the working jazz musicians of his day—was eccentric. Some believe Monk suffered from manic depression, with tendencies for severe introversion, and perhaps over-the-counter chemical dependencies—alcohol, sleeping pills—and amphetamines. One of Monk's bassists, Al McKibbon, once said Monk showed up at his house unannounced, sat down at his kitchen table, and didn't move or talk the whole day. He just sat and smoked cigarettes. That night McKibbon told him, "Monk, we're going to bed now," and he and his wife and daughter retired. The next morning, when they awoke, Monk still sat at the kitchen table in the same position. He sat there for another day and night without moving or talking or seeming to care about eating, just smoking. *It was fine with me*, said McKibbon, *it was just Monk being Monk.*

Monk: *We should let everybody take that "Little Rootie Tootie," let them take their time and get it. Ya know?*

Overton: *Sure.*

o

Monk can be heard pacing around Overton's half of the fourth floor, his heavy boots thudding at one-second intervals on the creaking planks that date to the building's construction in 1853, when Monk's grandfather Hinton was an infant living in slavery in Newton Grove, North Carolina, about five hundred miles away.

In 1880, Hinton Monk and his wife, Sarah Ann Williams, named their first son after his father, John Jack, and in 1889 they named their seventh child Thelonious. The scholar Robin D. G. Kelley, author of *Thelonious Monk: The Life and Times of an American Original* (2009), suggests the unusual name could have come from a Benedictine monk named St. Tillo, who was also called Theau and Hillonius. It could also have come from a renowned black minister in Durham, North Carolina, at the time, Fredricum Hillonious Wilkins, whose wife, Eula's, father was Reverend John Paschal, a notable black state senator. Hinton and Sarah named a daughter Eulah, so perhaps Thelonious was a derivation of Hillonious.

Thelonious Monk Sr. moved with several relatives to the tobacco and railroad hub of Rocky Mount, North Carolina, in the 1910s. There he met his wife, Barbara Batts Monk, who gave birth to Thelonious Jr. on October 10, 1917. The family lived in a Rocky Mount neighborhood called Around the Y, named for the Y-shape intersection of the Atlantic Coastline Railroad roughly a hundred yards from their home on Green Street (later renamed Red Row). In the tradition of renowned country blues musicians in North Carolina such as Sonny Terry, Blind Boy Fuller, and Reverend Gary Davis, Thelonious Sr. played harmonica and piano in almost cer-

tainly this syncopated, Piedmont rag style. Three and four decades later, Thelonious Monk would write compositions mimicking train sounds such as "Little Rootie Tootie"—the tune he's arranging with Overton in the loft.

The Monk family struggled. Jim Crow was in full force and, by all accounts, Thelonious Sr. and Barbara had problems with their marriage. Barbara moved to West Sixty-third Street in New York City in 1922 and took Thelonious Jr., his older sister, Marion, and younger brother, Thomas, with her. Thelonious Sr. tried to join the family in New York later in the 1920s but returned to North Carolina for medical or personal reasons. After 1930, the family apparently lost contact with him. They may have assumed he was dead. Rumors in the family indicate that he was beaten beyond recovery in a mugging or, having a wicked temper, participated in a violent beating himself and was committed to an asylum, or both. In any case, according to various extended relatives, Thelonious Sr. spent the last two decades of his life in a mental hospital in Goldsboro, North Carolina, not far from Newton Grove, before dying, as his death certificate indicates, in 1963. Many relatives visited, but his wife didn't and his kids were not known to do so either.

○

Monk: *Nobody {in the band} would have to be showing how fast they can read. No sight-reading or something, you know. Just take one bar, and work on it.*

Overton: *Like sight-reading Stravinsky.*

Monk, sarcastically: *A sight-reading contest, we'll have a sight-reading contest.*

Overton: *It's going to be hard, man.*

Monk: *It's generally good to tell cats that, ya know. And they really figure it out. You know, clashing notes, sometimes reading something they*

can't read perhaps, or understand how it sounds or goes or nothing. Let 'em listen to the record, you know? You do that by letting them listen to the record.

There is a pause of a minute or two as Monk continues pacing around the room, his footsteps maintaining a rhythmic pattern underneath the conversation. He doesn't sound so eccentric on these tapes, at least not in the one-on-one sessions with Overton. When the full band showed up for rehearsals in the loft, Monk went quiet, a bandleading technique certainly, indicating his preferences to his musicians with body language rather than words. The drummer Ben Riley told me in 2007 that he heard Monk talking more with Overton on these tapes than he did in four years of being in his band.

<p style="text-align:center">o</p>

Monk's wife, Nellie, joined the family in 1947, and she moved into the three-room apartment on West Sixty-third Street with him, his sister, Marion, and his mother. These three women protected him and allowed him to live a life focused almost exclusively on his music and family. *He was lucky that he lived with {us},* Marion said once. *You've got to have somebody behind you when you are following one road, because otherwise you can't make it.* Monk and Nellie lived with his mother until she died in 1955, when he was thirty-eight years old. Around that time the noted jazz patron Baroness Pannonica de Koenigswarter entered Monk's life and added herself to the team of female caregivers.

Monk's music owes something to his devoutly churchgoing mother. Some say the syncopated Harlem Stride style is the foundation of Monk's music. That's not false; it's just not the deepest root. Lou Donaldson, a member of Monk's band for the 1952 recording of *Carolina Moon*, said to me once, *My father was an AME Zion minister in Badin, North Carolina, and the Albemarle area, and*

one of the reasons I was so drawn to Monk's music was because I recognized right away that all of his rhythms were church rhythms. It was very familiar to me. Monk's brand of swing came straight out of the church. You didn't just tap your foot, you moved your whole body.

In addition to gospel, Monk blended blues, country, and jazz, then tied it together with a profound, surprising sense of rhythm, often using spaces or pauses to build momentum. The idiosyncrasies of his music made it difficult for some fans and critics who considered his playing raw and error-prone. Those criticisms came from European perspectives in which piano players sat still and upright in "perfect" form. Monk played with flat fingers and his feet flopped around like fish on a pier while his entire body rolled and swayed. In the middle of performances, he stood up from the piano, danced, and walked around the stage. Then he rushed back to the piano to play, sticking a cigarette in his mouth just before he sat down.

○

Monk: *That's three arrangements. You know, all of them are crazy, all of them are cool, you know, so far. They sound all right to me, they sound all right to you? Huh?*

Overton: *Pardon me?*

Monk: *All three of them sound all right, like they are.*

Overton: *Crazy, yeah. It's very clear to me, yeah. "Friday the Thirteenth." "Monk's Mood." "Crepuscule with Nellie." "Thelonious."*

Monk: *"Crepuscule with Nellie," all we need are about two choruses on that. We end up everything with that or something, end the set with that. You know, there ain't too much you can do with that, you know, it's just, you know, it's just the melody and the sound, you know, a couple of choruses.*

Overton: *Yeah, well, how do you want to do that, Monk?*

Monk: *I'll play the first chorus. Let the band come in and play the*

second chorus and finish that. And then we get up, you know, and get
our bread and quit.

　　[*Laughter.*]

○

In 1963, Monk made a remarkable appearance with Overton at the
New School in New York, broadcast live on the public station
WNET, Channel 13. Back in the loft Smith put a microphone next
to his television speaker and recorded the audio. Monk demon-
strated his technique of "bending" or "curving" single notes on the
piano, the most rigidly tempered of instruments. He drawled single
notes like a human voice and blended them to create his own dia-
lect, like making "y'all" from "you all." "That can't be done on
piano," Overton told the audience, "but you just heard it."

PART VII

AILEEN MIOKO SMITH

In April 2010, I attended a conference called "Mercury: A Hazard Without Borders" at William & Mary in Williamsburg, Virginia. I was drawn there by the appearance of Aileen Mioko Smith, Smith's Japanese-American second wife and the co-author of their 1970s project that documented the tragic effects of corporate mercury pollution in the Japanese fishing village Minamata (the poison affected fetuses, leaving unharmed mothers with deformed babies). We had traded e-mails for years but had never met; she lives in Kyoto.

At the conference, Aileen gave a keynote speech, and an exhibition of twenty-five vintage Minamata prints by Gene Smith opened at the university's Muscarelle Museum of Art. The show included ten more vintage prints from other parts of Smith's career such as Pittsburgh, Albert Schweitzer, Haiti, and Smith's children. Taken together, the work represented Smith's ongoing intrigue with human hands, instruments of tenderness, creativity, and destruction.

The exhibition featured a stunning presentation of the greatest photograph of Smith's career, *Tomoko Uemura in Her Bath*, a

portrait of a mother bathing her deformed young daughter, an image compared by many to Michelangelo's *Pietà*, with industrial critique layered in. By the time I began researching Smith in 1997, this image had been pulled from public circulation by Aileen, who owns the copyright for all of the Minamata materials, because of increasing pain expressed by Tomoko's family from the public exposure of this photograph. It wasn't meant for commercial calendars and postcards, not even for the aesthetic trial of museum walls. Not now, at least. I'd never seen a print of the image outside of Smith's archive in Arizona. This conference's emphasis on education and awareness, not art as object and commodity, allowed her to approve the inclusion of it.

A coincidence of circumstances at this exhibition that would be nearly impossible to reproduce again—the large size of the *Tomoko Uemura in Her Bath* (the print measured twenty-five by forty inches), the spotlighted presentation of it, and my surprise to see it—caused me to be moved in a manner that I thought had been worn smooth by years of research. Or, perhaps, this was simply the best print of this image that I'd ever seen. In any case, I came away with a clearer understanding that Tomoko and her mother were in a very small room and how close Smith must have been standing to them in this devastating and tender scene; how much trust Tomoko's mother must have felt toward him and Aileen; that, although Smith was in such poor physical condition in those years, he could manage to craft such a print; and that this print was the culmination of his life and work, all of his passions and interests along with darkroom techniques coming together in one printed picture. No need for a complicated sequence of images. This one would do. His life's work was complete. It was okay for him to die now.

o

Toward the end of the evening, Aileen and I walked out of the museum and sat down on the steps of a campus building across the street. She was fifty-nine years old at the time and could have passed for a woman at least a decade younger.

I first met Eugene in August 1970 when I walked into his loft on Sixth Avenue, Aileen told me. *At the time, I was in college in California and I had a summer job with a Japanese film crew that had been hired by a big advertising agency in Japan and their client was Fuji film. I was the coordinator for this ad that would focus on two photographers, and Eugene was one of them. Fuji paid him two thousand dollars. At the time, he was involved in putting together a large retrospective exhibition of his work and I think he needed the money to finish that exhibition.*

I walked into the loft with the Japanese gentlemen, and they immediately said what an honor it was to meet Eugene, et cetera. I was their translator. He looked at me and said, with a twinkle in his eye—he always had a twinkle in his eye—"What about you? Have you ever heard of me?" I said, "Noooo, I haven't," and we both smiled and laughed. That started the conversation.

For the next two days, we did the film work and he laid down his philosophy and his passion and his feelings, everything that he felt was important. He just set it out. The film crew wanted him to talk passionately and he did. He talked about photography and art and journalism and his belief in those things. And I was listening.

At the end of a couple of days, I realized his exhibition was deeply behind. It was going to be a six-hundred-print show called Let Truth Be the Prejudice, *as you know, at the Jewish Museum. Today I still have some questions about that title; it doesn't seem like the right title. Back then, I was naive. I didn't even know that six hundred prints for a photography show was such a large number. I had just turned twenty. Eugene was fifty-one and he was very, very exhausted. He was very much in pain, physical pain from all the injuries he'd had in his life, war injuries, many operations.*

I saw the situation and I immediately felt, "Oh, wow, somebody's got to save this." I later learned that in Eugene's life there was always somebody that came along and found him and said, "Oh my God, I've got to help this person out." I was just one among many that came along and felt that.

There were a number of other young people in their twenties helping him on this show. He announced that when he finished the show he would commit suicide. He saw this exhibition as the conclusion of his life and work. As it turned out, our work in Minamata was that conclusion. If I had been older when I met him, or if I'd been from a different family background, I'd have said, "Thanks, but no thanks," and left. But rather than go back to college in California, I stayed. Thanks to staying, though, I learned as much as I did.

In the loft at the time, he had about fifty sets of filthy bedsheets stuffed in corners, closets, and drawers all around the place. When sheets were dirty, he bought new ones, but he wouldn't throw out the old ones. He'd just stuff them away somewhere. I don't know what he thought he was going to do with them. We spent almost all the time in the darkroom. What comes to mind immediately are the red darkroom light and Dexedrine, which he always popped to keep awake; the all-nighters, the constant odor of hypo {a darkroom chemical}, and McGregor scotch—he drank one bottle every day. There was always music—he played opera or jazz on the record player, always.

Eugene was incredibly inefficient. But if you look at his negatives, you can see a man with a very clear mind. There is a rhythm in his negatives as opposed to the chaos of his life. You can see him building to where he wants to be and actually getting there. He builds up to an image and then releases and winds down. There's so much attention given to his printing—you know, printing while jazz or La Bohème *is blasting on the stereo—and that's valid. But he was very musical when he was shooting, too.*

Aileen's mother was Japanese and she was raised in Japan for

several years as a kid. She said that Smith felt like he was from Japan in a former life. So when the couple traveled there in 1971, taking *Let Truth Be the Prejudice* with them, it was a "yearning for homecoming" for them both, she said.

Not long after the couple landed in Tokyo, they decided to embark on the project in Minamata. Smith's long wish list of seventy-three projects that he gave John Morris upon joining Magnum in 1955 had included Portuguese and Japanese fishing villages as potential subjects. He would be able to check off one of the projects from the list with a book that was an instant classic in the history of photography and a landmark in global pollution awareness.

We got married and my first household as a wife was with Eugene in Minamata, she said, laughing. *What a way to start my life as a wife. It wasn't meant to last from the start. We spent seventy percent of our money on scotch for Gene, film, darkroom chemicals, and printing paper. Only thirty percent was for food and basic human needs.*

Aileen and I talked for about an hour and we made tentative plans to meet each other in Minamata later that year. I had one last question for her: Did she write all of the text in the Minamata book?

Her breath seemed taken away. For the first time all day, in which she had been a sharp public figure at the conference, she looked open and shaken. She said, *In all these years of talking about Minamata, nobody's ever asked me that.* She paused to gather herself.

You must understand, I'm not an artist. I never had goals of being an artist, not before Eugene or after. I was like his manager, just trying to get things completed, doing whatever had to be done.

That is why the Minamata project wasn't another of Smith's grand failures. Aileen wouldn't put a number on the percentage of the Minamata project work—photos and words—that are hers. She's listed as co-author and that says enough.

Aileen and Gene were together for four and a half years. *The project was our baby, finishing the book kept us together that long,* she said. She removed herself from intimacy with Smith more cleanly than most people did, before ordinary expectations of him took root, which probably explains why she remains sympathetic to him today, her memories unsparing while still caring for him, his legacy, and his family.

Smith received his greatest worldwide acclaim for the Minamata work in the few years before he died in 1978, traveling around Europe and the States soaking up the adulation. His archive is full of fan mail from that period, many young photographers gushing. In several interviews he admitted that Aileen made up to fifty of the photographs in the book. In his will, he left her ownership and copyright of those materials; the rest of his life's work went to his estate.

Aileen later remarried and had a daughter who was born in 1985. For the past four decades, she's been an international spokesperson and activist for antipollution initiatives.

20

INTERPRETER NEEDED

In April 2010, I e-mailed Simon Partner, professor of Japanese history at Duke and director of the university's Asian/Pacific Studies Institute, to ask for help finding a translator to accompany me on my trip to follow Smith's footsteps in Japan. He suggested that I post an advertisement on H-Japan, an international online scholarly discussion group devoted to Japanese history and culture. With Simon's editorial input I drafted a notice and he posted it for me:

> I am seeking a Japanese-English translator/assistant to travel with me in Japan and the Pacific during the approximate period of October 25–November 8, 2010. I am completing research for a biography of photographer W. Eugene Smith. The trip will follow in Smith's footsteps to Minamata, Tokyo, Saipan, Okinawa, Leyte, Iwo Jima, and Tarawa. We will be accompanied by Smith's former wife Aileen Mioko Smith on some parts of the trip. My biography is the culmination of thirteen years (and counting) of work. I am looking for excellent Japanese language skills, a helpful personality, and an interest in the topic. All expenses paid. Japanese residents preferable.

I received more than fifty responses. Most of them were from bilingual graduate students seeking work that paid. Not many of them expressed distinct interest in the content of my project.

Then, on May 7, a unique response caught my eye. It was from Tom Gill, a British professor of Japanese studies at a university in Yokohama. He told me I'd be hearing from his eighteen-year-old Japanese-British daughter, Momoko, and he encouraged me not to discount her because of her age.

A few days later, I received an engaging, articulate letter from Momoko, who told me she would be taking a gap year before entering college. She said she was a jazz drummer enthralled by what she'd seen of Smith's photographs of musicians to go along with his fabled work in Japan and the Pacific.

Momoko's e-mail query was the most affecting one I received, and she followed up with a couple more to see if the job was still available. We arranged a telephone conversation. She told me she was born in England and spent her first five years there, then ten years in Japan, before three for high school in Santa Barbara. Her eloquent articulation of interest, plus persistence, impressed me. I asked Simon Partner if someone that young could be an effective interpreter for me in Japan. He responded that if she was good enough, then, yes, she'd be fine.

Everything pointed toward a forty-four-year-old white American man traveling in Japan with an eighteen-year-old Japanese-British woman. It never occurred to me the parallels, that Smith was fifty-three when he went to Japan in 1971 and that the Japanese-American Aileen was twenty-one.

MEETING AT NARITA

My trip plans changed in the summer of 2010 when I learned that civilians were allowed access to Iwo Jima only one day each year and the next opportunity would be March 16, 2011. Since the productive conflicts in Smith's art—his unresolved tension between art and journalism—matured while he was photographing combat and living in the Pacific during the war, I needed to see that rock formation that juts above the surface of the Pacific Ocean, a tiny, surreal locus for the war of all wars where Smith made a classic war image for *Life*'s cover, among others. There's no way I can relate to the terror and carnage Smith saw and sensed on Iwo Jima—the smells being the least possible to imagine—but at least the light would be the same.

I signed up to reach Iwo Jima through a military history tour filled with veterans and their families, scholars, and other enthusiasts of war history. The day trip would begin in Guam on March 16, 2011, at 4:00 a.m.

○

Momoko adjusted to the new schedule. She planned to meet me at Tokyo's Narita Airport on the afternoon of Sunday, February 20.

By then my trip had grown from two weeks as originally conceived to thirty days. She would travel with me for twenty of those days.

Momoko later told me that I had impressed her, during the interview process for the job and the lead-up to meeting her in person, by not seeming to care how she looked. I didn't ask for a photo and she knew I wasn't on Facebook. Before meeting her at Narita, I had told her to look for a man six feet five inches tall, with dark, thinning hair, glasses, and a goatee. I figured it would be easier for her to find me than me her.

I made it through customs and found an open place to rearrange my luggage. Barely off the plane, I immediately felt Narita to be the most foreign place I'd ever been, my international travel to that point in my life limited to Europe. I had only slept a couple of hours during the sixteen-hour flight and was delirious. Then I heard a soft, hopeful voice, a high-pitched voice, a rounded hum, calling my name in an accent that seemed mostly British, with a hint of Asian: *Sahm? Sahm? Is that you, Sahm?*

She was taller than I had imagined, at least five foot six, with long, thick black hair hanging straight, well past her shoulders. She wore a thin white scarf with purple dots and a long gray winter jacket (it snowed in Tokyo that week) over faded jeans. Her hair and scarf framed her face, her expression as open and eager as her voice had been in writing and on the phone. She carried a large, full shoulder bag made of muted woven earth colors and a small piece of black rolling luggage was at her feet. She later told me she was nauseated with nervousness at that moment, but it didn't come across to me.

o

Momoko figured I'd be tired and hungry from the travel, so she brought several varieties of dried seaweed and two bottles of

water. We collected ourselves, caught up with each other since our last e-mail exchange a couple of days before, and she found our bus to Tokyo.

Momoko took a window seat with me next to her on the aisle. The bus pulled away from the curb and meandered out of the airport toward the highway.

She turned to me and said, *What is it about Smith's nature that interests you?*

Wow, the answer to that question is long and digressive, I replied.

Well, we've got about ninety minutes to the hotel and then we've got three weeks. There's plenty of time.

We spent the first couple of days in Tokyo wandering around, getting our bearings on Smith's former neighborhood in Roppongi and seeing Hitachi City. We would begin our interviews on the third day.

22

KAZUHIKO MOTOMURA

On Thursday, February 24, 2011, Momoko and I met Kazuhiko Motomura, who was seventy-eight years old at the time, a retired employee of local governments in Japan, a career civil servant who looked the part: simple, conservative, and fastidious in his attire, understated and polite in his countenance. He was born in 1933 and grew up in a rural area called Saga, near Nagasaki, then he and his family moved to Tokyo in the 1960s after he got a job in the city's department of tax and revenue.

In his spare time, over two decades, Motomura set up his own publishing company, Yugensha, and published five monumental photography books, each a carefully refined masterpiece. Three are by Robert Frank (*The Lines of My Hand*, 1972; *Flower Is . . .*, 1987; and *81 Contact Sheets*, 2009), the most intimate and personal and arguably the best books of Frank's career. Another is by Jun Morinaga (*River: Its Shadow of Shadows*, 1978), who was Smith's assistant on the Hitachi project in Tokyo in 1961–62. The fifth is *Television: 1975–1976* by Masao Mochizuki, 2001.

Each Yugensha book came in an edition of fewer than one thousand copies and was priced at what amounts to more than

one thousand dollars apiece. Today, a seller of rare photography books in Santa Fe, New Mexico, lists a complete set of all five Yugensha books for $15,000, which might be a bargain. In 2008, Christie's auctioned a copy of *Flower Is . . .* for $6,250. Motomura's books were published in impeccably crafted boxes, and each page displays stunning reproduction values that make evident his utter lack of concern for commerce. This modest, practical tax officer made landmarks from his hobby.

Motomura met Smith through Morinaga, and then he met Frank through Smith. He built a trust with Frank that American curators and editors couldn't, which allowed Frank to reveal earnest, intimate emotions in a manner not seen anywhere else, not even in *The Americans*, which is more calculated and positioned. Motomura's innocence, his lack of striving on the world's art stage, must have allowed that to happen. In that way, he reminded me of Hall Overton.

o

The day before our meeting with Motomura, Momoko had spoken with him on her cell phone. He told her that we should meet him at 11:00 a.m. the next day on the sidewalk outside a bookstore in Shinjuku. When we arrived, Motomura was already there. An average-looking man around five foot five, standing on the sidewalk in the most megadeveloped strip in Tokyo—Times Square squared—he toted an enormous backpack, carrying, we learned a few minutes later, copies of each of his oversized books, plus notebooks and archival materials.

I assumed that Motomura had selected this meeting place because of proximity to this bookstore, but that wasn't the case. No movement or curiosity was expressed toward the store, which sold mass-market books and magazines. Instead, Motomura led us down a nearby stairwell into Shinjuku Station, the busiest

train station in the world, where we walked a maze of tunnels for fifteen or twenty minutes, taking several ninety-degree turns in both directions, before hiking up another stairwell and out onto the sidewalk in front of a department store several blocks away. We walked inside and took an indistinct elevator up eight floors where the doors opened into a nearly empty coffee shop.

My first question was part introduction, letting Motomura know that I was deeply moved by his books, by his extraordinary efforts that seemed so impractical. I told him I was curious how he came to be so deeply interested in photography and then act on it in such a sophisticated manner.

He listened to Momoko's translation. Then he paused for several seconds. Finally, he chuckled and said, *I wonder. I don't really know myself.*

All three of us laughed. I asked him about his childhood and youth in Saga.

It isn't the sort of place that stands out, he said, chuckling again. He didn't seem quick to elaborate, so I asked what were his passions as a young boy.

Since I was small, I liked to collect things.

Were your parents collectors? I asked.

No, not at all. He laughed.

What did you collect as a kid?

I collected books, Motomura said, warming up. *Around the time Japan lost the war in 1945, I was in my first year in middle school. I wanted to make a bit of money, so I bought a lot of manga comic books and started a little book-rental store. That's how I earned my allowance. I used most of the money to see films. I think maybe I became interested in photography because I watched films. The more films I watched, the more I began to choose movies by filmmakers. Akira Kurosawa, all of his films, especially* Seven Samurai. *I watched any film. I was living in a rural area in Saga, where there weren't many movie theaters, so not all*

*the foreign movies imported to Tokyo were shown there. Japanese movies
all got played, but not so much the foreign ones.*

He went on to explain that after he moved to Tokyo, the
photography world opened up for him. He even enrolled in the
Tokyo College of Photography and, among others, he met Jun
Morinaga and the two became friends.

*Morinaga was born in Nagasaki {in 1937}, but his parents were
from Saga, as well. And during the war with America, when it was
beginning to look like Japan was going to lose, Morinaga's mother moved
out of Nagasaki and back to Saga with her children, including Mori-
naga. Morinaga's father and older sister, who was about twelve years
old, stayed behind in Nagasaki, where his father had work. His sister
was there to take care of their father. Both of them were killed by the bomb.*

Later that year of 1945, the eight-year-old Morinaga returned
to Nagasaki with his family to see the devastation. Fifteen years
later, in 1960, when he was twenty-two, Morinaga began making
abstract photographs documenting extreme pollution and decay
along Tokyo's muddy rivers, dead plants and animals covered in
oil and muck. These are the images published by Motomura
in *River: Its Shadow of Shadows*, within which Morinaga wrote these
words (translated from the Japanese by Momoko), "At first I felt
it was a world of death. Later in my work photographing the
ugliness, I realized that there were microorganisms living there.
As I got closer, I realized there were thousands of little insects
moving around. The world I had presumed to be a world of
death was in fact a world of life. Neither way of looking at the
river is wrong."

Motomura told me, *Morinaga took photos of dead dogs and cats
floating in the river, things like that. I think his memories of his father
and sister killed in the Nagasaki bombings are reflected in those photos.*

In 1961, in the middle of his three years making those
photographs of the polluted rivers, Morinaga began a one-year

assistantship with Smith on the latter's Hitachi project in Tokyo. Smith was two decades older than Morinaga at the time, but the two men's interests in humanity and the contradictions of industry couldn't have been more overlapping.

When he showed those photos to Smith, said Motomura, *Smith was in tears. Smith wanted to see Nagasaki and they went there together.*

Morinaga's work in Tokyo foreshadowed Smith's decision to document the fallout from polluted waters in Minamata. I asked Motomura how it came to be that he helped fund Smith's early work in Minamata. His roundabout answer went like this:

Well, I'd seen Robert Frank's photos, his book—The Americans. *I was very interested in that. Then I thought that there must be more great photos of Frank's out there, that he must have more great photos that weren't published. I myself wanted it. I wanted to see more of Frank's photos*—not just The Americans. *So if more books had come out after* The Americans, *I would have just bought those books instead of making them myself.*

So, Smith was the one who introduced me to Frank. When Smith expressed his interest in taking photos in Minamata, I told Smith I would pay for his living expenses in Japan if he introduced me to Robert Frank. I only helped him out in the beginning. Then he got support from other sources.

Minamata is a rural area. The cost of living isn't very expensive. So I got locals to look for a room for him to rent. At that time there was a girl named Aileen—a half Japanese, half foreigner—who came with Smith as an assistant. Once they were situated in Minamata, she took care of a lot of things and I wasn't so much involved. I had a flat in Harajuku at that time, which Gene and Aileen used as a base when they were in Tokyo. I received many prints from Eugene as payment.

I asked Motomura how his relationship with Frank was established.

I have almost all of Frank's, if not all of the different versions of

The Americans. *It was published many times in different countries. I have all versions. The very first one was in France and I think it was the best one. The title was* Les Something. Les America*? Something like that. At first, American publishers didn't make the book because they thought there was prejudice against America. And then I happened to have the connection with Smith, who was friends with Frank. So I was introduced to him by Smith in 1971.*

When I first went to New York to meet him, Frank had stopped making photo books. He was working on movies. He said to me, "What on earth are you doing here?" And I told him I wanted to make a new book of his work. He just kept shaking his head. Finally, I asked, "Is that okay?" and he said, "It's okay. Let's make it a good book, and I'll send you a dummy." And he did.

A few weeks after our trip around Japan, Momoko wrote me an e-mail from Bali in which she remembered Motomura:

"He was clearly committed to making these books available to the world. What remained unclear, however, even after your persistent quizzing, were his motivations—what made those particular books special to him. He resisted a clear answer, or he didn't have one. All these things combined with his constant efforts to divert attention from himself—he thought it was a cheerful joke when you told him you wanted to write an article about him—made me see him as a man whose actions were guided by real passions, rather than by expectations, egotism, fears, or anything like that. I will always admire him for that."

REIKON

One afternoon Momoko and I met eighty-four-year-old Taeko Matsuda, who founded Cosmo Public Relations in 1959 and soon gained the powerful Hitachi as a client. In 1961 she hired Smith to photograph the company.

Matsuda had grown up in a Tokyo orphanage run by her parents, who encouraged her to learn as much English as she could. In 1951, she moved to Los Angeles to attend college at the University of Southern California, one of the first Japanese students to do so. Then she spent six years working for NBC in Los Angeles. When we met her in Tokyo in 2011, she retained a glamorous touch. She brought out photographs of her and Gene in Tokyo in 1961–62, and she looked gorgeous and charming. I could see her fitting in well in Los Angeles, sporting sunglasses, driving a convertible in Santa Monica. Her English was broken when we met her; she said she'd lost much of it from lack of use over the years.

Matsuda arrived in Los Angeles the same year that *Life* published Smith's epochal essays "Spanish Village" and "Nurse Midwife." Smith would never be so famous as he was in the early

1950s, still less than a decade removed from his work covering the Pacific theater in the war.

Matsuda was a fan of Smith's, first because of the sensitivity with which he'd photographed the war, then enhanced by his portrayals of the two cultures foreign to him in "Spanish Village" and "Nurse Midwife." Menace and fear were the norms of those times (McCarthyism, the beginning of the Cold War, the space race with its esoteric paranoia), but none of that was found in Smith's visual reports on traditional Spain and rural black America. If anything, he found menace and fear when he focused his lenses on industry and urban life in Pittsburgh in the mid-1950s. You could say that Smith's Pittsburgh was a study of mainstream America, a study of *Life*'s readership, and the mirror he held up was troubling. Using different styles and techniques and subjects, Smith and Robert Frank were operating on the same plane at the same time.

Matsuda told us Cosmo put up Smith and Carole in an apartment owned by a man who ran a stationery store in Roppongi Station. *The apartment was above a flower shop,* Matsuda said, *and when Gene and Carole got here Gene said, "Wow, we travel halfway around the world and we're still living with flower shops, that's great."*

Matsuda said that Smith's efforts on the Hitachi project lasted four times longer than expected. When Hitachi would complain about Smith's belabored operation, she would say to them, *"He can't help it; it's what he does; just wait."*

Hitachi had to wait almost two full years to reap dividends on their investment. *Life*, welcoming Smith's return to its pages after an eight-year absence with a celebratory op-ed, published a layout of his Hitachi photographs under the title "Colossus of the Orient" on August 30, 1963.

The publicity Hitachi received from the *Life* spread redeemed everything for Matsuda and her client. The degree of warmth she

expressed toward Smith was notable. She missed him. Perhaps that was just her style, being in the business of marketing and publicity, but that's not the feeling I received from her.

○

A few days later, Momoko and I went back to meet with Taeko Matsuda again. This time, she had with her a former employee of Cosmo who ran errands for Smith, Hiroshi Shimakawa, who went on to become a novelist. His father had been killed during the war when Shimakawa was three years old and he, like many Japanese, considered Smith's photographs from the war to be sensitive and sympathetic, not American propaganda. His memories of Smith contained revealing details that I hadn't heard from anyone else:

I spent a lot of time cleaning up empty liquor, beer, and wine bottles and going to the store to get Gene and Carole their everyday necessities, including whiskey and beer for Gene. One thing I remember the most is that Gene actually broke his leg somehow but he didn't realize he'd broken it and he couldn't remember how. He didn't feel much pain because of the alcohol. Then he finally went to the hospital and there was a fracture. It wasn't a bad fracture, but still, he just worked right through it. Another thing I remember is that Gene brought with him all these old novels that were yellow on the side, faded yellow pages.

Shimakawa then changed his tone, musing on Smith:

There's a mysterious, sublime, divine force present in people like Gene. But there were two sides to him. One side had the felt beauty of a true professional artist. The other side was lazy and indulgent. The good side usually came out when he had a camera in his hands. Carole really took care of him. He couldn't have made it through a day without her. Basically, I was helping her help him.

You could say that Gene saw these two sides to everything in everything he did, including his Hitachi and Minamata work. Postwar Japan

was going through tumultuous times. Large companies like Hitachi and Chisso (the company that dumped mercury into the bay in Minamata) were growing and small ones were trying to survive. Gene saw sacrifices being made by people at lower levels. Smith saw alive things in dead things. That's a big theme for my novels as well. Living and dying, light and shadow, conscious and unconscious, the subconscious floating around.

*There's a Japanese word—*reikon*—that has two parts, two meanings. One meaning is that it means something like ghost, or spirit, a divine outside presence. The other meaning is more like soul or interior or being inside the individual. Is there an English word that contains both of those things? In Japanese, it's one word, both elements contained in one word. But sometimes there's tension between them. I think Gene had problems with this tension. He had trouble reconciling light and dark. Over the years he gradually fell further and further into the dark side. He had a generous soul that made him a bigger person than a cameraman, but he couldn't nurture that side.*

<div align="center">○</div>

While Smith was in Tokyo with Carole Thomas he used reel-to-reel equipment that he brought with him from the loft (there are tapes from the lead-up to his trip in which he can be heard telling Carole he wants to take a recorder) to make tape recordings at a rapid rate in their apartment in the Roppongi section of the city. He also picked up new equipment from Hitachi. In Smith's archive, there are approximately 175 hours of sound recorded during his one year in Tokyo. These tapes suggest that Smith would have made obsessive tapes inside 821 Sixth Avenue even if there weren't an important after-hours jazz scene there.

The Tokyo tapes contain a similar variety of sounds found on the New York loft tapes: random recordings of local Japanese radio broadcasts as well as American radio captured through the Far East Network and Armed Forces Radio. There's a lot of Japanese

folk and classical music and Japanese deejays playing American music like that of Nat Cole, Billie Holiday, Fats Waller, and Duke Ellington, primarily African Americans. There are many American radio news reports on JFK's presidency; the activities of George Wallace; the Andy Griffith and Bob Hope shows; CBS Radio Workshops featuring the work of writers like Mark Twain and Noël Coward. And there are many tapes that Smith labeled "Roppongi window," in which he put the microphones in the window and recorded ambient street sounds, during which Smith can be heard puttering around, he and/or Carole typing letters, him working in the darkroom with Jun Morinaga and/or Masato Nishiyama, or just Smith and Carole talking, often about *The Big Book*.

o

Momoko and I met seventy-six-year-old Nishiyama in Roppongi on Saturday, February 26, 2011. He showed us around the neighborhood. The building where Smith lived and had a darkroom no longer exists, but the Chinese restaurant where Smith often ate, Kohien, remains, owned by the same family, but in a different, more modern location. Nishiyama took us there and he ordered the same noodle soup that he said Smith ordered every time. He described the neighborhood as it stood in 1961 and 1962:

The tallest buildings were four to five floors and they were walkups, he said, *made of wood planks and bricks. Now, look at them all, skyscrapers that must be forty or fifty stories. There's no evidence of old Japan here now. Back then, there would have been more old and modest buildings. The real estate boom of the 1980s and 1990s destroyed everything.*

Nishiyama was born in Tokyo in 1935, and he grew up balancing interests in audio and visual elements. *I used to build my own radios,* he said, *so I really hit it off with Gene because of his inter-*

est in radio and obviously photography. He first learned of Smith's work from *Life*. Life *was my greatest teacher,* he said. Then, in the late 1950s, Edward Steichen's vast exhibition, *The Family of Man*, for the Museum of Modern Art, which contained a number of images by Smith, traveled to a Tokyo department store and Nishiyama went to see it several times.

Both Nishiyama and Morinaga met Smith through Taeko Matsuda and Cosmo. Shimakawa told us, *Nishiyama and Morinaga treated Gene like he was a god.*

o

Later during our Tokyo stay, Matsuda called Momoko and asked if we had time to come see her again. The day before we left Tokyo for Minamata, we paid her a third visit, during which she handed me an envelope. *Don't open now,* she said to me in English, *don't open now.* Outside on the sidewalk, I opened it to find 200,000 Japanese yen (about $1,500). I used the money to buy two of Kazuhiko Motomura's books, the one by Morinaga and one by Robert Frank. Motomura gave me a discount.

24

TAKESHI ISHIKAWA

On Tuesday, March 1, Momoko and I arrived in the town of Minamata, which sits on the Yatsushiro Sea in deep southern Japan, quite a departure from Tokyo. It would be something like a first-time Japanese visitor to the States going from New York to Gulfport, Mississippi.

Minamata's seaside mountains were a bigger presence than I had imagined they would be. Mist and fog hung in the valleys and a cold, stiff breeze greeted us when we rolled in. We found the Super Hotel in the center of town, dropped off our bags, and wandered around. At three in the afternoon, the streets were vacant, except for children walking home from school in uniforms, with raincoats and backpacks, and numerous alley cats. We had no map or directions and yet had no trouble finding the front gate of the massive industrial complex of Chisso, the company that dumped mercury waste into Minamata Bay for several decades in early and midcentury, poisoning the fish that had long been the lifeblood of the area. The toxins from these fish affected the wombs of pregnant women, resulting in several thousand (at least) deformed babies. Later in the week

we were told, "The babies absorbed all the poison and saved the adults."

The next day, Takeshi Ishikawa, now age sixty, flew down from Tokyo to join us. In 1971, Ishikawa was a photography student in Tokyo when Smith's exhibition *Let Truth Be the Prejudice* opened in a Shinjuku department store. Ishikawa saw publicity portraits of Smith and one day noticed him walking down the street. He approached Smith, and, though Ishikawa spoke little English, ended up spending three years working with Gene and Aileen in Minamata, documenting the effects of Minamata disease. He remains close to Aileen today, and she vouched for me (she had intended to meet us in Minamata but at the last minute couldn't make it). Ishikawa dropped everything and spent three days with us.

Ishikawa grew up in a family of rice farmers in rural Ehime Prefecture on Shikoku, the smallest and least populated of the four major islands of Japan, about five hundred miles southwest of Tokyo. Painting first drew his interest, then design, but the gadgetry and handcraft of photography took hold. His kindness and sincerity give him a childlike quality: he's quick to laugh and quick to become misty-eyed, especially when talking about Smith's compassion and generosity. People in Minamata lit up when they saw him, including disease victims he'd known for forty years. By our last day together, communicating almost entirely through Momoko, it was as though the three of us had known one another for a very long time.

"Mr. Ishikawa might be the oldest person I know who could feel like a brother to me," wrote Momoko to me later. "One memorable time in Minamata, I caught a glimpse of the boy in him. He had been arranging a casual dinner with some disease victims and care workers, who were old friends of his. You and I were planning to go to the dinner at first, but the exhaustion of the

previous two weeks had caught up with us, and we were seeing the same group the next day anyway, so we decided to give it a miss. When I told Mr. Ishikawa that we were passing on the dinner, I remember vividly the look on his face. We had burst his bubble. He was increasingly shaken by each word I spoke, like a plant that sways in resistance as heavy raindrops roll off its leaves one by one. After some struggle, he was able to summon a mature voice of understanding. He hadn't told everybody that we would be there, so it wasn't that he feared people would be offended or upset. He just really liked the idea of everybody getting together, friends old and new, having a nice meal and some drinks. But the next morning when I caught up with him at breakfast, he seemed to have already forgotten about it. He was looking forward to the day ahead with us."

Ishikawa took us to see the tiny plot of land where Gene and Aileen had lived in Minamata. He had stayed there, too, for a short time, before moving to another house close by, where he set up a darkroom for Smith. For years after the project was completed and the Smiths had moved away, there was a sign out front indicating "Eugene Smith's House."

About one hundred yards from the house, with railroad tracks running in between, there is a neighborhood store run by the Mizoguchi family. Smith bought a fifth of Suntory Red whiskey and ten bottles of milk there every day. Ishikawa sometimes ran that errand. The same family still owns the store. We went in, and Ishikawa asked Mr. Mizoguchi if he remembered Smith. Momoko told me he began talking about Smith casually, as if he still lived there. Mr. Mizoguchi's wife disappeared into their house and emerged with a scrapbook that featured two vintage prints given to them by Smith as gifts. The prints, simple pictures of neighborhood cats, bore his trademark warmth and range of black and white tones. It was better than looking at his prints in a museum. Mr. Mizoguchi picked up the phone to

call people who would remember Smith. We met with one of them, Takeru Uchigami, the next day. Smith had photographed his wedding, and the picture made it into the eventual book *Minamata*.

After the visit to the store, Ishikawa called a taxi so we could head back to the hotel. The dispatcher knew our location when Ishikawa said, *Eugene Smith's house*. In the taxi to the hotel, he said, *I always knew that Gene and Aileen would never last as a couple. It wasn't healthy. Gene drank all the time, he wasn't in good shape, and they fought a lot. For some reason, it felt like they pretended to get along in front of me. Even after they returned to New York, once I went to visit them and they were separated by this point, but they didn't tell me. They pretended to still be together just for me. It was like they didn't want to disappoint me or something.*

Later that night, we had dinner with seventy-six-year-old Kyoko Mizoguchi (no relation to the store owners), whose family owned the house in which Smith and Aileen lived. Kyoko's sister Junko, twelve years her junior, maintained a crush on Ishikawa at the time. They shared laughs about what might have been. Kyoko had another younger sister, Toyoko, who died of Minamata disease at age eight. When Kyoko was very young, before Junko and Toyoko were born, she often went fishing for the family dinner. Mercury-infected fish swam slower and closer to the water's surface, Kyoko said, making them easy catches. She described coming home with baskets of fish, to the delight of her parents.

When Gene and Aileen Smith moved into the house of Kyoko's family, there was a shrine to Toyoko installed in the main room. They didn't take it down. In a picture of that room by Smith, you can see the shrine in the background, and Ishikawa faces the camera. Aileen sits at the opposite end of the table in a striped robe.

Toward the end of dinner with Kyoko, she used the word *yurei*, "ghosts," to describe Momoko and me, ghosts of Gene and

Aileen, she said. The comments came with warm tears in her eyes. The next morning, Ishikawa, Momoko, and I visited Kyoko's house to look at some of her pictures and other tokens from the early 1970s when Gene and Aileen were there. Again, she called Momoko and me ghosts. Then she used the same term Shimakawa used, *reikon*, the spirit that departs the body after death and continues to exist, often becoming a benevolent ancestor, or a *yurei*. When we said goodbye and walked down the narrow street away from her house, Kyoko stood outside and cried. She waved until we were out of sight.

○

When I conduct oral history interviews, I don't use a script. I prepare at length, and questions arise naturally, but I purposefully don't use a list. This method can mean forgetting to ask something important. But it's worth the risk because it also can enable an unusually emotional and revealing exchange, something real. My father, a doctor of internal and family medicine in my small hometown, Washington, on the coast of North Carolina, always said, "If you listen to patients long enough, they will tell you exactly what is wrong with them."

In the late 1990s, I attended a talk by the documentary filmmaker Errol Morris, who put it this way: "If you ask a question, you'll get an answer to that question. But sometimes if you just sit there silently for long enough you'll get answers to questions you wouldn't know how to ask."

This method can baffle some. Once I interviewed the jazz bassist Butch Warren in the offices of NBC News in Washington, D.C., down the hall from the studio of *Meet the Press*. Warren was from D.C. and had moved back there during a long disappearance not unlike Ronnie Free's. He'd played in Monk's bands that rehearsed in Smith's loft in 1963 and 1964 and he was also a

comrade and occasional bandmate of Sonny Clark's. There were specific things I wanted to ask him, but I also wanted to develop a trust with him. I like to begin a process of building trust by asking a subject about their parents and grandparents. A simple question like that can trigger a conversation that never really stops. It can get emotional. An interview expected to last an hour can go on for a long time, even months and years. In the interview with Warren, I never came anywhere close to that. Two high-level NBC staffers for *Meet the Press* sat in on the interview (they were generous enough to have arranged it—Warren didn't have a telephone at the time) and they seemed dumbfounded by this method. They felt awkward, squirmed, paced restlessly around the back of the room, appeared to feel uncomfortable for me and for Warren, and jumped into the space I left open.

o

Before my trip to Japan, I'd never tried this method of interviewing through an interpreter and I never considered any emotional consequences of relying on Momoko's ears and voice to act as mine.

Each morning we met for breakfast in our hotel. She'd arrive with a list of questions and comments she'd jotted down overnight. We'd go over everything and prepare for the day ahead. She would make whatever phone calls and send whatever texts or e-mails were necessary. Then we'd make our way to new locations and listen to personal and often intimate stories.

Momoko had never done anything like this but her experiences growing up on three continents made her good for this line of work, adaptable and street-smart. It was clear she earned the trust of a variety of people on our trip. Meanwhile, I'd never felt this level of dependency in my adult life.

By the time we were in Minamata, when Kyoko was calling us ghosts of Gene and Aileen, I was caught off guard by feelings that had grown powerful and unsettling. On a long-planned journey halfway around the world, I was following Smith's footsteps on a level unrealized.

25

SAIPAN

On Wednesday, March 9, Momoko and I were back at Tokyo's Narita Airport bidding farewell. She returned home to Yokohama and I headed to Saipan.

Two days later, on the afternoon of Friday, March 11, I was swimming off Saipan's Red Beach, where U.S. forces had come ashore in 1944, when a man with a bullhorn emerged and bellowed, *Earthquake in Japan! Tsunami coming! Please get out of the water! Earthquake in Japan! Tsunami coming! Please get out of the water!*

We were ordered to evacuate to the upper floors of our hotel. Everyone was hysterical. I considered putting on my running shoes and jogging up into the nearby mountains. Instead, I walked swiftly to the hotel's laundry room where I'd put two loads in driers before swimming, my bathing suit the only thing I had that was clean. I noticed that several Saipan locals didn't seem the least bit worried. I inquired. *The water around this island is so deep, it absorbs all tsunamis. Not a problem.* Feeling better, I put on dry clothes, assembled my computer and valuables in my backpack, and took the stairs, as ordered, to the upper floor of the

hotel, where a large group of Russians were wearing orange life preservers (nobody knew where they'd gotten them).

It was eerie to leave Japan after a deep and emotional experience and to barely escape the disaster and fallout, to be safe on a small island nearby. Momoko was stranded in Yokohama (her parents in the U.K. and the States), unable to get a flight out for nine days. I felt responsible for her being there alone. The damage to Japan's nuclear plants conjured images of World War II's atomic bomb destruction and it stirred my new impressions from chemical-ravaged Minamata. Intertwined were thoughts about the new friends I made by following Smith there.

o

Saipan is part of the Northern Mariana Islands along with Guam, Tinian, and Rota. It may have been the battle of 1944 there when the twenty-five-year-old Smith became an artist. Saipan is a beautiful, lush patch of rock and thick vegetation, only twelve by five miles, with a deep history of indigenous people, the Chamorro, who lost control of their lives forever when the Spanish colonized the place in the early sixteenth century. Japan took it over in 1918, and the United States invaded and wrested control during World War II. Smith made some of his first vintage war photographs during that battle. The paradoxes of war, beauty in destruction, and the fate of hapless individuals against the onslaught of collective forces are themes that Smith investigated for the rest of his career, and his trademark printing techniques—producing tensions between dark and light shades that John Berger once said were essentially "religious" for Smith—may have been conceived on those battlefields, too.

In Saipan, I met an intriguing man who helped me track Smith's path through the island. He was the sixty-three-year-old historian Don Farrell. Before I left home, I was told he's the best

battlefield tour guide in the Pacific. He grew up in the American West, in various places like Spokane, Washington, and Billings, Montana. He was sent to military reform school for making explosives. He was kicked out of reform school for making corn liquor. He roamed around and eventually worked his way through Cal State Fullerton with a degree in biology in 1974. He moved out to the Northern Marianas in 1977 to teach math and science and later worked for the local government in Guam. Farrell's wife of thirty years is a native Chamorran, and they live on Tinian. This place is his home; he's not a visiting scholar. He wrote the local history textbooks they use in schools here. He became tearful telling me a story about a Chamorran family that was elated to find the only known photograph of their grandfather in one of Farrell's textbooks. It was the first time the family had ever seen that picture.

Farrell looked like a cross between a ZZ Top guitarist and Colonel Sanders—the long white beard, potbelly, and a twinkle in his eye. He walks around in flip-flops, shorts, tropical shirts, and loves to drink beer. He's also an authority on the local cannabis. He described the situation for me this way:

{The island of} Palau has the best soil for growing buds, and they know how to take care of their plants. Their buds are gold. They have the highest levels of tetrahydrocannabinol of any buds in the world. That old California stuff that everybody thought was so great back in the seventies is water compared to this. You can't get good smoke on Guam or Saipan because the soil is no good. Smoke growers in those places buy soil in the hardware store and grow their buds in fifty-gallon metal drums in their backyard. If you go to almost anybody's backyard barbecue out here you'll see a drum like that.

I've watched Terrence Malick's Pacific war movie *The Thin Red Line* countless times. Sometimes when I'm working in my home office, I'll play it on the TV in the background, like it's

classical music or opera. The rhythms of its audiovisuals are sub-
lime. Some critics are annoyed by Malick's use of voiceover, though.
I know what they mean: While Malick's camera pans an intricate
jungle root system with sunlight cascading through foliage, a
character's voice softly murmurs such things as "What's this war
in the heart of nature?" "Why does nature vie with itself?" "Who
are you to live in all these many forms?" It can be tedious. But
after spending some time with Farrell walking through the lush
jungles of Saipan, Tinian, and Guam, pondering the unimagina-
ble carnage that took place on these tiny dots of land populated by
uninvolved natives, abstract thoughts and unpredictable images
begin floating through your brain. The insanity of war is still ac-
cessible there today. The European theater is more definable, like
a football game, with home territories and borders; the Pacific is
hazy and hallucinatory.

Farrell and I were standing on the top of Saipan's fifteen-
hundred-foot Mount Tapochau looking down into Death Valley,
imagining Smith crawling around with his cameras, and he
squinted at me like a pirate and said, "Are you getting what you
need?"

I wasn't sure what I'd find on the islands to help me tell
Smith's story. But I think what I discovered may say more about
him than did the oral-history interviews from the previous three
weeks in Japan.

o

I arrived in Guam only to learn that my day trip to Iwo Jima was
canceled by the American and Japanese embassies because of the
earthquake and nuclear disaster in Japan. I was disappointed,
but I understood the decision. A government-sanctioned sight-
seeing trip to a remote island was inappropriate while Japan was
undergoing the tragedy, no matter that 140 Americans had gath-
ered there for the trip, with a mirror group in Tokyo.

Smith made stunning photographs of the Iwo Jima battle, and I am disappointed to finish this book without seeing that tiny piece of volcanic rock poking up out of the ocean. It measures only four and half miles long and two and a half miles wide, yet we (Americans) had 800 ships and 200,000 troops off its shores in 1945. The absurdity of that reality must have impacted young Smith, who was from landlocked Kansas: We're fighting the war of all wars over *this*?

Before I left home, my friend the writer Allan Gurganus handed me Jun'ichirō Tanizaki's *Seven Japanese Tales*. In a story called "A Portrait of Shunkin" (1933), a bitter student attacks his beautiful, blind, and masochistic music teacher, leaving scars on her face. Her lover, also her apprentice, pokes his eyes with needles to blind himself so he can't see her blemishes. It was the ultimate absolutist Japanese aesthetic gesture. The photographer David Vestal, Smith's friend and advocate, once told me that Smith's problem was that what he saw wasn't there, so the camera had no way of recording it. That's why he had to work so hard in the darkroom. All of Smith's master prints made after the war have an absolute white color and an absolute black somewhere in the picture, often in several places. This is the graphic war John Berger saw playing out in Smith's work. Maybe combat in the Pacific did that to Smith. Maybe it was in his blood. Whatever the origin, for Smith, there was more truth in darkness.

PART VIII

A LONG TELEGRAM

As Smith's isolated deliriums grew over time in the loft, he began sending telegrams to a live overnight radio talk show hosted by Long John Nebel on WOR in New York City. The show mixed legitimate guests such as Jackie Gleason and Ed Sullivan with discussions and phone calls from listeners about UFOs, voodoo, hypnotism, and other paranormal activity and esoterica that reflected the paranoia of the postwar times, often more intense among people awake from midnight to 6:00 a.m., which is when, of course, Smith was often up and listening. His telegrams, ranging from passionate to comic, were efforts to connect with the outside world and glean some affection. Nebel would read the telegrams over the air, and Smith would be back in his loft with a microphone next to his radio making tapes.

Here's one from 1960:

Long John Nebel: *All right, this is good, this is from Gene Smith, one of the greatest photographers: "I'm busy photographing out of my window and within the building adding to a present nine thousand or so photographs. Some are fuzzy, and so am I. But I still find the challenge exciting. As usual I'm enjoying and arguing the show. Personal regards,*

Gene Smith." Isn't that nice? I'll tell you, he got so hot one night, he went forty-three bucks {$360 in 2017 money} for a telegram. He got so steamed. I don't know if I said something or if somebody said something, and, he, you know, boom, he fired it right up. Forty-three dollars. We checked it because it was so long.

I couldn't be sure of finding the precise telegram Nebel referred to—there were so many—but one from May 1961 piqued my interest. It's the longest one I found recorded from the Nebel show on Smith's tapes and it reveals one of Smith's lifelong preoccupations: health care and caregiving.

Nebel: *I have a telegram here . . . from . . . This is a long one, too, in fact, we're making bets on what it cost . . . this was sent to us by one of the top photojournalists in the country. I know he listens from time to time and he's Eugene Smith, he's without a doubt one of the finest photojournalists in the country.*

Nebel then spends a few seconds debating on the air about whether to have his producer, Anna, read the whole telegram because it will take so much time. Finally, he agrees to have Anna read it in its entirety.

First, believe my respect for medicine as one of the great professions. Secondly, let me harp on a point or two and I hope Western Union does not transpose the word "harp" in this particular sentence. It should easily be known that adequate medical facilities are not available to a great many persons in some parts of this country. Some of these areas I personally know from having walked and ridden and worked with and pitied those who are lucky enough to be visited in what was a maximum of even being noticed.

I have also seen a baby brought to a medical center highly fevered and dehydrated and needing an immediate transfusion, for which the relatives {I imagine there's a word left out there} inadequate in blood, were told that they would have to find a way, forty miles out, to where they were acquainted, and forty miles back with a blood donor if one

could be found. Also arose a resentment of me when I stepped from my role of photographic journalist to give the transfusions. A resentment in this particular instance because the child was Negro. However, this is not racial. For in a respected name hospital in this our great name city I too had to commit "malpractice" and to "coerce" the one overworked nurse. And when she tried to stiffen the rules, attempting surprise at my still being there when a doctor arrived at midnight to visit the patient I was interested in, I had to re-coerce—or more kindly and probably more accurately in the emergency of the circumstances—to convince the doctor it was acceptable for the nurse to allow me to stay and aid through the night with the patient, and so I stayed. My medical knowledge being based upon my journalistic experiences, a lifetime interest, and the fact of having been shot up during the war, I stayed giving glucose injections and blood transfusions as well as constantly checking such as the drainage tubes making certain they were not causing poisons to dam up in the critically ill patient. The nurse took a chance because she was desperate, without help. The doctor took a chance because he knew something of my background and he knew as well as I that hospital ethics in such emergency would have listed the death of the patient under the heading of "unforeseen complications." Rather than face the scandal of what it was necessary for the three of us to connive in so that the patient might live. (I can almost feel the itch of some of my fellow journalists on certain publications.) It was gambling for the life of the patient with two or possibly three careers directly at stake and with the reputations of the hospital as well. Yet if man at times is not willing to gamble reputation and future that there may be life or if a good name must be maintained at the cost of lives, my conscience would be heavily burdened with conflict. Please, where the wrong is, I am not fully prepared to enter into and I must make clear that I reluctantly would have understood if the doctor and nurse had insisted upon playing by the same rules, even it had cost the life of this person close to me. It was a dilemma not of their making. I am simply concurring in my belief that much advance must be made within

our medical system and with a slight carping at too early a dismal of the vast need for conscientious general practitioners and that good medical aid is often more a theory than a fact.

In fact, in those years since I was shot up, and since the doctors who originally worked on me have died, I have had a most difficult time trying to find medical treatment for conditions from the injuries which still plague me. And I have been fortunate in personal advice as to who to go to from medical friends well thought of in high places. It is all difficult and though I can wend my way with some understanding and appreciation of these difficulties, it must be terribly bewildering to the outsider. But I still give deepest honor to the profession of medicine and have sympathy with its problems as long as its practitioners refrain from cold-blooded arrogance. Arrogance is not a fault of your panel tonight for their apparent sincerity comes over quite strongly.

Warmest regards, and I hope this telegram is easier to read, W. Eugene Smith.

A guest on Nebel's show: *He did a thing on a midwife in a rural, Negro section of the South . . . it was one helluva story.*

Nebel: *This man, he can do no wrong with a camera. Just great, a fantastic photographer.*

MAUDE CALLEN

On Tuesday morning, December 11, 2012, I rented a Chevrolet Impala and drove out of Chapel Hill, North Carolina, on I-40 East toward Berkeley County, South Carolina, a former slave plantation region near the coast where Smith photographed his 1951 *Life* essay "Nurse Midwife."

Smith's patented reputation as a sensitive maverick, which took root in his twenties with combat photography in the Pacific theater of World War II, cemented into legend with "Nurse Midwife." It was Smith's first assignment after being confined to Bellevue when police found him wandering the Upper West Side naked (or in his boxers; accounts differ) in the spring of 1951. With a new opportunity to prove himself, Smith bucked *Life*'s editors and South Carolina officials by choosing Maude Callen, a black woman, as the focus of his essay instead of a white subject. He first undertook two weeks of midwife training to gain perspective, then he followed Callen for two and a half months, gaining her trust and friendship. (By contrast, James Agee and Walker Evans spent less time, two months, in rural Alabama in 1936 for their epic book, *Let Us Now Praise Famous Men*.) The resulting

twelve-page essay in *Life* inspired $27,000 in unsolicited dona-
tions to Callen, helping her to build a new clinic. For the rest of
his life, Smith called "Midwife" his favorite story and Callen the
most impressive human being he'd ever met.

o

I wasn't sure what I could learn by visiting Berkeley County
sixty years after "Midwife" was published and twenty-two years
after Callen had passed away at age ninety-two. Before leaving
home, I consulted the Duke biologist Matt Johnson, who studies
peat moss in Hell Hole Swamp, which is in the center of Callen's
former house-call territory.

*The Hell Hole Swamp Wilderness area is part of the Francis Marion
National Forest. It first shows up as "Hell Hole" on a 1775 map, which
disproves the theory that Francis Marion, "The Swamp Fox," named it
during the Revolutionary War. Somewhere I read that the name "Hell
Hole" goes back to the native people who reportedly would not enter "The
Hells," believing there to be spirits at work.*

The swamp is a combination of pine savannah and pocosins, John-
son told me. *The latter is a uniquely Southern coastal plain ecotype:
cypress, or* Taxodium, *trees rise and loom over a dense understory choked
with smilax, locally called "blasphemy vine," and standing water that
frequently has several species of* Sphagnum, *or peat moss, floating in it.*

*During Prohibition, the pocosins are where the moonshiners would
hide from the authorities. The moonshine economy pretty much kept the
area afloat, so to speak. Every year, on the first weekend in May there's
the Hell Hole Swamp Festival in nearby Jamestown. The mascot of the
festival is a moonshine still made out of a car radiator. They reenact
abductions of moonshiners by the feds.*

*From April through October the mosquitoes are thick enough to
make a dense gray cloud everywhere. It's a truly nasty place to be, unless
you study peat moss. Even then, you need a machete and DEET. But*

Hell Hole Swamp is a weird place—in the thick of summer, the mosqui-
toes are actually absent due to the abundance of dragonflies. If you bring
some waders and stand in the center of the swamp, it can be a pretty serene
experience.

o

I peeled off I-95 after passing South of the Border. Driving back
roads seventy miles farther southeast, I entered northern Berke-
ley County on SC-52 heading down toward the crossroad with
SC-45 at the little town of St. Stephen. Spanish moss dripped
from the pines and live oaks as I passed scenes of abandoned gro-
cery stores, pawnshops, roadside hair salons, rotting wood-plank
barns, and the wild, unfarmed fields that mark today's rural
Southern landscape.

During Maude Callen's midcentury prime, SC-45 and SC-52
formed the axis of her daily travels, with the then-dirt 45 con-
necting her home in Pineville with Hell Hole Swamp ten miles
to the east, and 52 reaching south thirteen miles to Moncks
Corner, the county seat with a population of around five thousand.
Callen put 36,000 miles per year on her car driving around this
poverty-stricken area, which was nearly 90 percent black. Her
job was a necessity; the doctors from Moncks Corner wouldn't
go there.

I met a man named Keith Gourdin (pronounced *guh-dine*) at a
trailer-size redbrick post office on Highway 45 in Pineville, which
is not a town anymore, just a word on a green sign you pass when
driving by. Gourdin was born in Berkeley County in 1940. He
and his wife, Betty, have been married since 1962 and live today in
a mansion built in Pineville by his grandparents. His French Hu-
guenot ancestors settled in Berkeley County in the seventeenth
century and operated several cotton plantations there.

In the past decade, with his farming and land-management

slowing down, Gourdin has become a meticulous historian of Berkeley County, combing archives and memories. On top of his pool table, in a foyer with a fourteen-foot ceiling, Gourdin has built a toy model of Pineville at midcentury, replete with replica churches, stores, houses, railroad tracks, and roads, almost none of which still exist today.

As a child and youth, Gourdin lived two miles down Highway 45 from Maude Callen's house and the clinic that was built after Smith's essay. When he was sick and needed care, particularly procedures involving needles, he begged his mother to take him to *Nurse Maude* instead of the doctors in Moncks Corner. *She didn't make you hurt,* he said.

Gourdin was twelve years old when Smith's "Nurse Midwife" story was published in *Life* in December 1951. The piece created a stir in Pineville. *The staff at the post office had to work overtime to handle all of Nurse Maude's mail,* said Gourdin. *I remember people talking about how the carriers had to make several extra deliveries per day to keep up with the mail she was getting from around the country. She was getting mail from around the world.*

The mail was delivered on a dirt road. Today that road is paved, though seldom traveled. Decay and desolation prevail, just as they did after Sherman plowed through. Maude Callen's patients have moved to Atlanta, Raleigh-Durham, Charlotte, and Wilmington. Her former clinic is forlorn.

o

A week before I visited Berkeley County, South Carolina, I learned that in 1936, Time Life's magnate, Henry Luce, and his wife, the flamboyant Clare Booth Luce, purchased a three-thousand-acre former slave plantation there, only twenty miles from the poverty-stricken region where Smith made "Nurse Midwife." The Luces made the plantation their vacation estate.

Did Smith know this? Is that why he fought so hard to celebrate Maude Callen amid the pages of *Life*'s whitewashed Madison Avenue ads, to shove the contradictions in Luce's face? It's hard to know. Nothing in the archive indicates that he knew.

In 1949, the Luces donated part of the Mepkin Plantation to the Trappist Abbey of Gethsemani of Kentucky, creating Mepkin Abbey. When Henry died in 1967, his body was laid to rest in the property's gardens. After Clare's death in 1987, her body was buried next to his. As a serial graveyard explorer, I knew I had to see these graves, which together with Callen's abandoned and crumbling clinic form an unlikely set of Berkeley County monuments to *Life*'s midcentury power, which Gene Smith both hated and needed.

I parked my car at the abbey and walked to the garden grave sites under a cold December mist. The understated, serene gardens were terraced in a series of semicircles down the bank of the Cooper River. I stood looking at the pair of Luce gravestones on the highest terrace, an eight-foot marble cross poised between them, while a young monastic sat meditating cross-legged on an oval stone wall that rings the graves.

28

BLANCHE DUBOIS AND LENA GROVE

I left South Carolina and hugged the Georgia coast and the Gulf coast of Florida for a few days. I was on my way to Mississippi and New Orleans for more site visits related to my Smith research, in particular to pursue his affinity for Tennessee Williams and William Faulkner.

Coastal towns are more appealing in winter. The light is clear, the air crisp, and the off-season demographic atrophy reveals a town's cultural skeleton and a more discernible pulse. In a small bar at the Village Inn on St. Simon's Island, Georgia, I listened to three older couples—all New York transplants, I learned—enjoy a familiar chat with the African-American bartender, who had grown up across the sound, in Brunswick. Clearly, this scene has been repeated, maybe for years. Another New Yorker, a customer at a crafts and antiques store across the street, made a splendid recommendation on the best seafood dive in town.

I left the island and made a daylong meander across south Georgia to Apalachicola, Florida, stopping to visit little stores here and there, to get hot water for tea, or just to soak up the sepia winter light. The route included towns such as Nahunta,

Hoboken, Waycross, Manor, Argyle, Homerville, Du Pont, Stockton, Naylor, Valdosta, and Quitman. It felt like I was seeing sites I'd never see again, either because I'd never come back or because next time everything would be gone. What's left behind after decades of farm attrition are churches and desperation. In Waynesville, a topless bar called Hootersville sat next door to the corrugated-aluminum Family Life Church, both looking repurposed and fleeting.

If the losers in the downsizing of southern American agriculture are the small towns, the winner is the landscape, wilder now perhaps than since the jungle was first cleared for farming several centuries ago. With the low winter sun shining sideways against upright surfaces—trees, weeds, barns and farmhouses and stores—the light colored scenes of decay. Even the small mounds of Georgia's red dirt cast little shadows, changing color and texture depending on whether they were front- or side- or backlit by the sun. In overcast conditions, a beautiful gray-brown filter was laid down over everything. If well-to-do Europeans once sent their infirm to the South of France to be healed by the sun and fresh air, the rural American South would be a good place to do that today.

o

After dark, I spent a couple of hours walking around downtown Apalachicola, a bygone coastal village known for oysters. The temperature was in the forties and fog filled the empty streets, blurring the Christmas lights. Owls called to one another. I followed the sounds of one pair until I was standing underneath a cell phone tower on the edge of downtown. Two owls were up there, hidden in the night fog. I listened to the perfectly repeating intervals of their call-and-response patterns, mesmerized. The next morning, I pulled the Impala onto Highway 98 and headed west along the Gulf shore.

○

Mississippi and New Orleans were on my horizon. *Light in August* and *A Streetcar Named Desire* were on my mind, which is to say, Gene Smith was back in the mix. The morality and narrative techniques of Faulkner and Williams influenced Smith's photography: he taped the text of Faulkner's Nobel speech to the wall above his desk in his dilapidated Sixth Avenue loft.

My destination was Laurel, Mississippi, southeast of Jackson and northeast of New Orleans. Laurel was the hometown of *Streetcar*'s fictional characters Blanche DuBois and her sister, Stella, and the site of their family estate, Belle Reve. It was Blanche's loss of Belle Reve after the war that sent her to steamy, bedraggled New Orleans to stay with Stella and her husband, Stanley Kowalski. The rest is theater history. I wanted to spend some time in Laurel and then follow Blanche's path into New Orleans.

The specter of Williams, beyond the nude-pool frolic that Smith photographed, has woven in and out of my research on Smith over the past few years. Whenever the playwright or his work showed up on radio or TV, Smith rolled his reel-to-reel tape recorder. He also wrote desperate letters to Elia Kazan, director of *Streetcar* and *Camino,* semiveiled pleas for help to, he thought, a kindred soul.

In *Streetcar,* Tennessee Williams has Blanche exclaim a line that could have come from one of Smith's letters or telegrams: "I don't want realism. I want magic! Yes, yes, magic. I try to give that to people. I do misrepresent things. I don't tell truths. I tell what ought to be the truth."

Blanche's nemesis was Stanley, the archetypical midcentury bowling-and-poker-night white male, a war veteran, a beer-and-a-shot shift worker who—post-Depression, postwar—suddenly

had cultural value as a consumer. The advertisements in Henry Luce's *Life* were aimed at men like him and their wives, people who found within their reach a higher rung. Thus, *Life* was Gene Smith's Stanley Kowalski, an inexorable, tormenting mainstream force. For two of his classic photo-essays—"Country Doctor" (1948) and "Nurse Midwife" (1951)—Smith ventured to remote regions in search of a different truth, to illustrate the anti-Stanley, the heroic, earnest dignity of solitary caregivers. It was the impulse of a romantic trying to show a better way. Like Blanche, Smith ended up in an asylum, twice.

Before I left home, Allan Gurganus had recommended that I take the audiobook of *Light in August* read by the actor Will Patton on my trip. Allan went on to compare Blanche DuBois to that novel's Lena Grove, pregnant and wandering around Mississippi looking for the father of her baby. *Faulkner and Williams both hailed from "nice" families a few generations down on their luck,* Gurganus told me. *The drive and ambition they attribute to their very different heroines, in* Light in August *and in* Streetcar, *reflect their own strange fates. The old order has faded and a new one is taking rank. These men were geniuses, born into dream-prone minor tribes from little towns in a defeated region. So Lena's search for a father for her child and Blanche's wish for the security of an oil tycoon who'll spoil her mirror their creators' quests. Each made a knight's gambit, each going in search of acknowledgment, recognition, a place of honor and dignity, a place to stand, in the reconfigured modern world.*

o

The founding industry in Laurel was logging, the bastard cousin of farming. The entire state of Mississippi was essentially cleared for farming, making it the third-largest timber-producing state at one time. Today, the population of Laurel has stabilized at around 18,000 after being 25,000 in 1970.

I drove the Impala around town for three days, and it felt
like there was a jacked-up pickup truck on my tail the whole
time, uncomfortably close. I couldn't shake them off. Constantly
checking the rearview mirror, irritated, I would pull over to let
one monster truck pass only to find another one immediately sniff-
ing my tail.

I checked into Wisteria, a bed-and-breakfast in a historic
white-columned mansion on a classic hardwood-canopied street
near downtown, across the street from the Lauren Rogers Museum
of Art, which was founded in 1923 as a memorial to the Rogers
timber family. The Rogers is as appealing a small museum as
you'll ever find, with a terrific library and an unusually good col-
lection of European and American art. In the half-abandoned
downtown, with Christmas decorations making things seem more
forlorn, not less, I found two upscale restaurants and a coffee
shop with fine tea and baked goods and Wi-Fi.

The next morning, over a delicious breakfast of eggs, fruit,
and sausage, I told the seventy-something B&B owner, Earl, that
later in the day I was heading to Mize, a town of a few hundred
people about thirty miles northwest of Laurel, to look for a rela-
tive's grave. Earl blinked and his face pruned with concern. *I
wouldn't be caught there after dark with those plates on your car,* he
told me. My rented Impala had Maryland plates, randomly. *That
place—Sullivan's Hollow {"holler," Earl pronounced it}—is not known
to be friendly to outsiders.* He paused then added, *Oh, well, you'll be
fine. It's not as bad as it used to be.*

o

Transfixed by Will Patton's performance of *Light in August*, I began
the process of tracking him down. By the time he called me from
his apartment near Union Square, I was packing to leave New
Orleans and to finish my Southern sojourn evoking Gene Smith.

Patton was born in South Carolina, and today he divides his time among Manhattan, the North Carolina mountains, and the South Carolina coast. He has a naturally subtle and pliable Southern accent, perfect for the varying voices and multiplying narratives of *Light in August*. He's not just performing the role of narrator, or characters like Joe Christmas or Lena Grove. He performs the whole complexity of Faulkner, with a hypnotic pacing of blues.

The first thing Patton wanted to tell me was the geographic irony of his reading experience: *They sent a limo to pick me up each day here at my apartment {in Union Square}. They drove me to a banal industrial warehouse area somewhere near Newark, New Jersey, and there I went inside and read Faulkner's prose about rural Mississippi. Something about that struck me as oddly comic. But once I started reading I forgot where I was. It took several days or a week of full-time reading to get it done. I knew it would be demanding, quite a challenge.*

Patton then mused on the draw of Faulkner for him.

One of the gifts my father, a former minister, gave me was a love for Faulkner. Go Down, Moses *was the first book that really got inside of me when I was a kid, and it never let me go. Then I read everything.*

Reading Light in August *for the microphone was a process of letting that book move through me. It enters your brain and your heart and comes out through your voice. It's a very intense experience. You live the book. It's a great privilege to be inside a work of art like that.*

I couldn't live through Smith's photographs in the way Patton did Faulkner's words. Photography is a different medium, the outcomes meant to be looked at, not so much performed like words or musical notes. Listening to *Light in August*, I could understand why Smith owned virtually the entire catalog of Caedmon Records, why he repeatedly played aloud the words of Edna St. Vincent Millay, Emily Dickinson, Arthur Miller, and others. For more

than two weeks of driving, Faulkner's words through Patton's voice intoxicated me. I found myself longing for the next back road where I could let the words saturate me. I would pick up a twenty-four-ounce Budweiser or Miller High Life can, drive to a remote site, park, shut off the engine, and just listen.

EPILOGUE

In October 2015, I traveled to Kremmling, Colorado, the last of my site visits researching Smith. Kremmling is the tiny Rocky Mountain town that had been the home of Dr. Ernest Ceriani, the subject of Smith's legendary "Country Doctor" essay for *Life* in 1948.

For years, I've noted that the words *doctor* and *documentary* come from the same Latin root, *docere*, or *doceo*, which means, variously, to care, to pay attention, to teach, to learn, to heal, to make appear right. Walking in Smith's and Dr. Ceriani's footsteps in Kremmling seemed like an appropriate way to complete this book.

I flew into Denver, rented a car, and drove two and a half hours northwest to Kremmling, crossing the Continental Divide on State Road 40 at altitudes over ten thousand feet, one of the most treacherous passes in the country, I learned later, and one of the most beautiful.

There were people in Kremmling who remembered Dr. Ceriani and Smith, including the sister of the little girl famously stitched up after a horse-riding accident. I drove around, sought Smith's original vantage points, researched local-history archives,

stayed in the same hotel where he stayed, and watched the World Series at the only bar in town.

I drove back to Denver to fly home. While there, I met Dr. Ceriani's son, Gary, now a successful attorney nearing age seventy (he was two when Smith photographed his father). I sat around the table with Gary and his wife, Mary Ann, with my audio recorder running for more than ninety minutes. They brought out some memorabilia, including several vintage prints that Smith gave to Dr. Ceriani. What I had learned in Kremmling is that Dr. Ceriani demonstrated undying devotion to his work over several decades as the only doctor in this remote region. He made house calls at all hours and he was almost never off. I quizzed Gary on his father's drive. Gary's thoughtful responses had to do with qualities his father inherited or learned from his parents, who were emigrants from Italy that found their way to pioneer life in North Dakota, rather than settling in cities like most Italians.

Then, when we were done, I turned off my recorder, packed my bag, and was preparing to leave when Gary made the most interesting and telling comment I heard in five days following Smith's footsteps in Colorado: "You know, I've never thought of this until now, but I believe there's a chance that my father felt *trapped* by Smith's work. Smith made him out to be a perfect human being in *Life* magazine. Then he had to live up to it."

ACKNOWLEDGMENTS

The Smith family, his archive, and the people who populate this book and my two decades of research have my foremost gratitude and respect. I couldn't have done anything without them. This line of work has been a privilege, an education, and a reward for its own sake.

Two editors made formative impacts on the manuscript while it was in progress—Nicole Rudick, over the six years of working with her at *The Paris Review*, and Scott Schomburg of Rock Fish Stew, over an intense twenty-one days in 2016 when I was traveling in Missouri, Minnesota, and San Francisco and working with him long-distance to reduce the text to essentials. Warm thanks to Paul Elie for seeing possibilities in my original proposal years ago and to Ileene Smith for shepherding a much different result, and to Stephen Weil, Jackson Howard, Maya Binyam, and everyone else at FSG.

Integral to this work over the years were Laurie Cochenour and her family, the Reva and David Logan Foundation, and the Logan family. Also, Sara Fishko and Bob Gill, Kate Joyce, Ben Ratliff, and Hank Stephenson; Dan Partridge, Lauren Hart, Courtney

Reid-Eaton, Tom Rankin, and Alex Harris; Chris McElroen, Brigid Hughes, Roland Kelts, Michelle Wildgen, Farnum Brown, Joe Henry and Melanie Ciccone, Ivan Weiss, Natalie Smith, Land Arnold, Jem Cohen, Anna Mazhirov, Paul Weinstein, Naomi Schegloff, Dale Strattman, David Simonton, Ken Jacob, Michael Rosenberg, and Betty Adcock and her late husband, Don.

Gratitude to the Center for Creative Photography at the University of Arizona for making available Smith's things (nods to Denise Gose, Leslie Squyres, Dianne Nilsen, and Carol Elliott) and to the Center for Documentary Studies at Duke University for giving me a base for fifteen years. Thanks to Steve Balcom and Lane Wurster of the Splinter Group. And ongoing gratitude to Jeff Posternak, Sarah Chalfant, and Andrew Wylie for bringing me in and standing by me patiently. Special thanks to Momoko Gill for her indelible impact. And thanks to Ann and Lex Alexander, who introduced me to the metal artist Leo Gaev, who turned the sink into a desk. This book is dedicated to Allan Gurganus, who, among many other manners of friendship and inspiration, handed me a worn copy of *The Quest for Corvo* in 2009.

Finally, all my love to Courtney Fitzpatrick and Parker Fitzpatrick Stephenson—here's to the next two decades.

A NOTE ABOUT THE AUTHOR

Sam Stephenson is a writer and documentarian who grew up in Washington, North Carolina. He is the author of *Dream Street: W. Eugene Smith's Pittsburgh Project* and *The Jazz Loft Project: Photographs and Tapes of W. Eugene Smith from 821 Sixth Avenue, 1957–1965*, as well as many pieces for periodicals such as *The New York Times, The Paris Review, Tin House*, and the *Oxford American*. He is a former fellow of the National Endowment for the Humanities, a two-time ASCAP Foundation Deems Taylor/Virgil Thomson Award winner, and a Lehman Brady Visiting Joint Chair Professor in Documentary Studies and American Studies at Duke University and UNC–Chapel Hill. He founded Rock Fish Stew Institute of Literature & Materials in 2013, authored *Bull City Summer: A Season at the Ballpark* in 2014, and coauthored *Big, Bent Ears: A Serial in Documentary Uncertainty*, an experimental collaboration with *The Paris Review*, in 2015. He lives in Durham, North Carolina, with his wife and their son.